PAPER 1972–2017

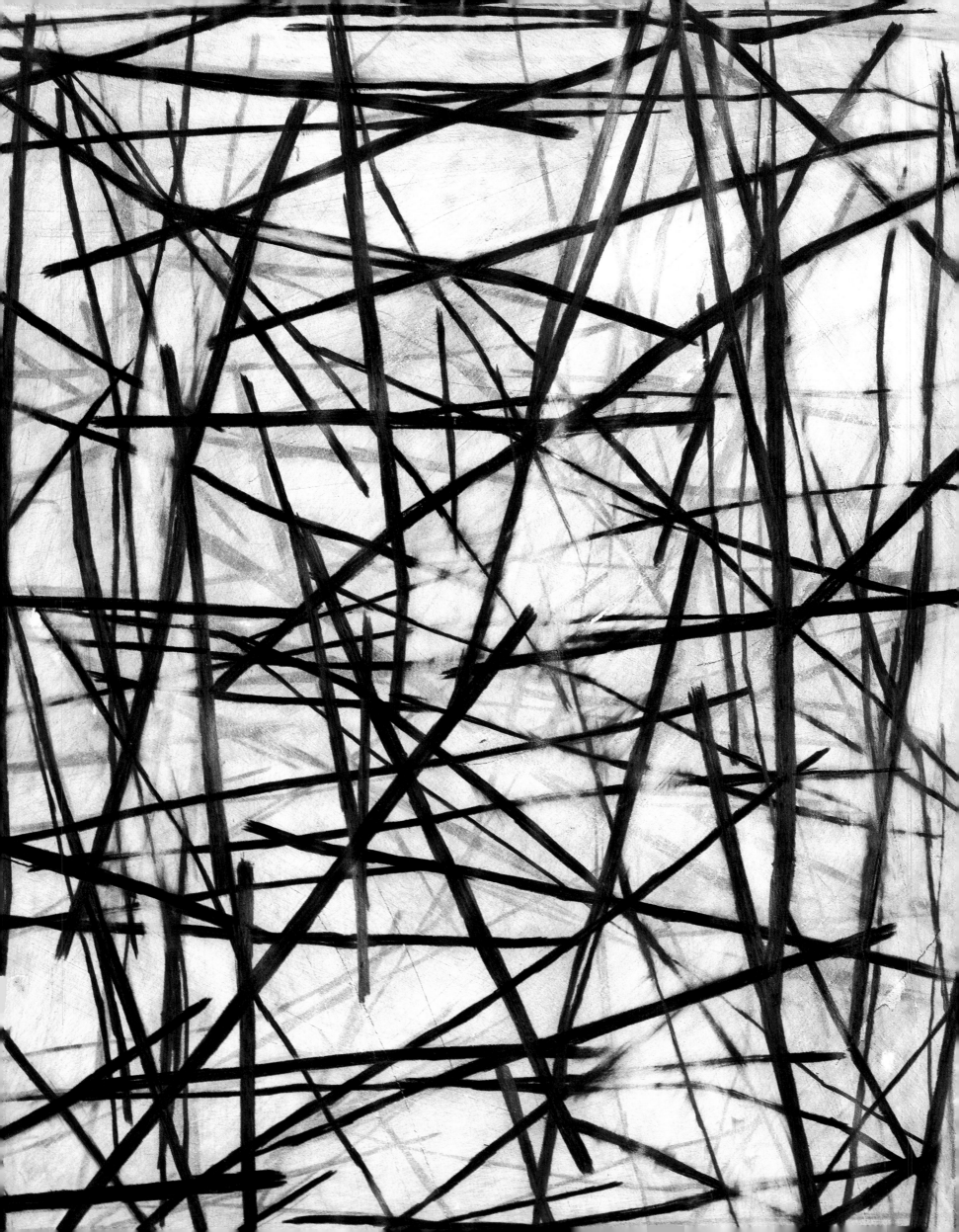

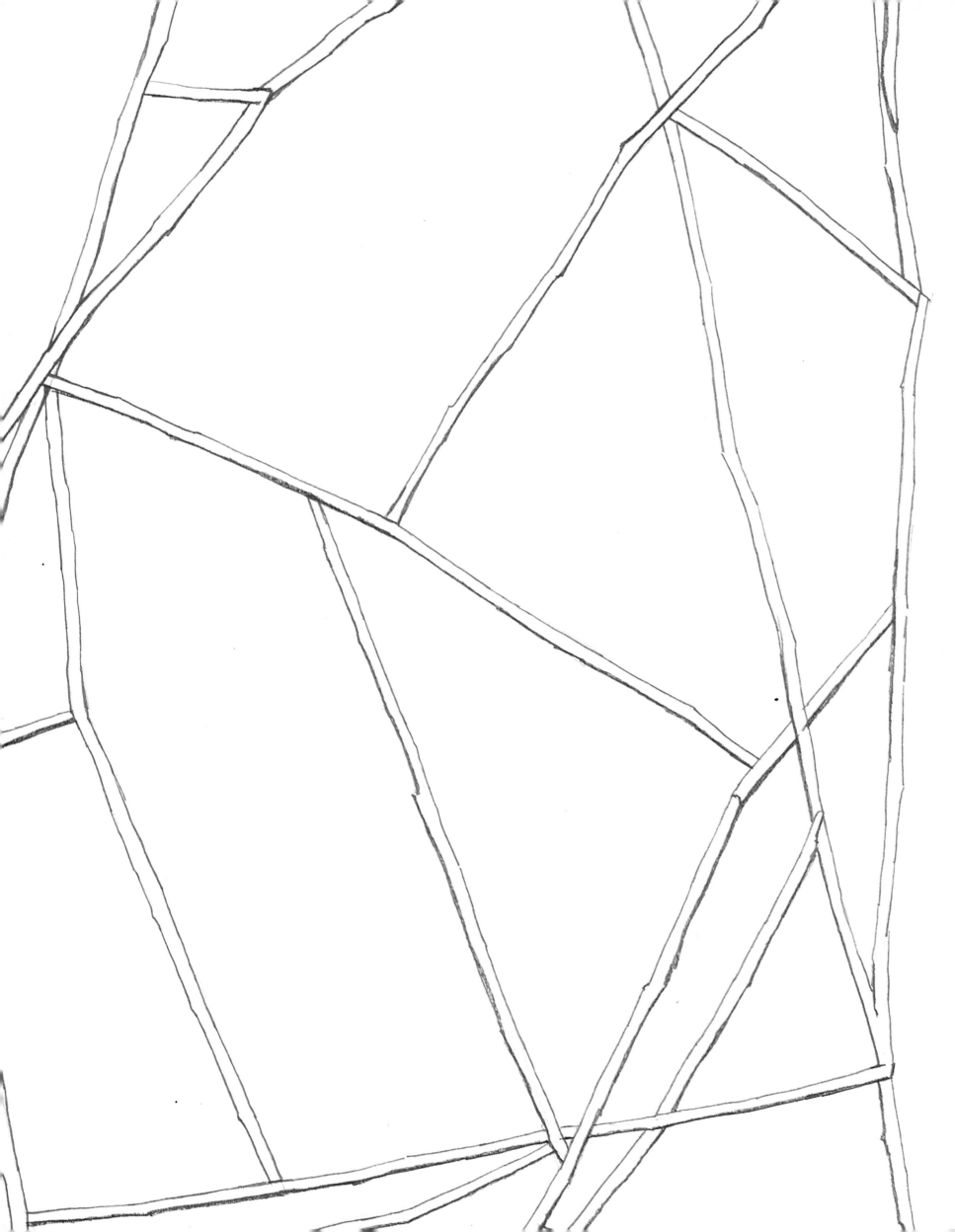

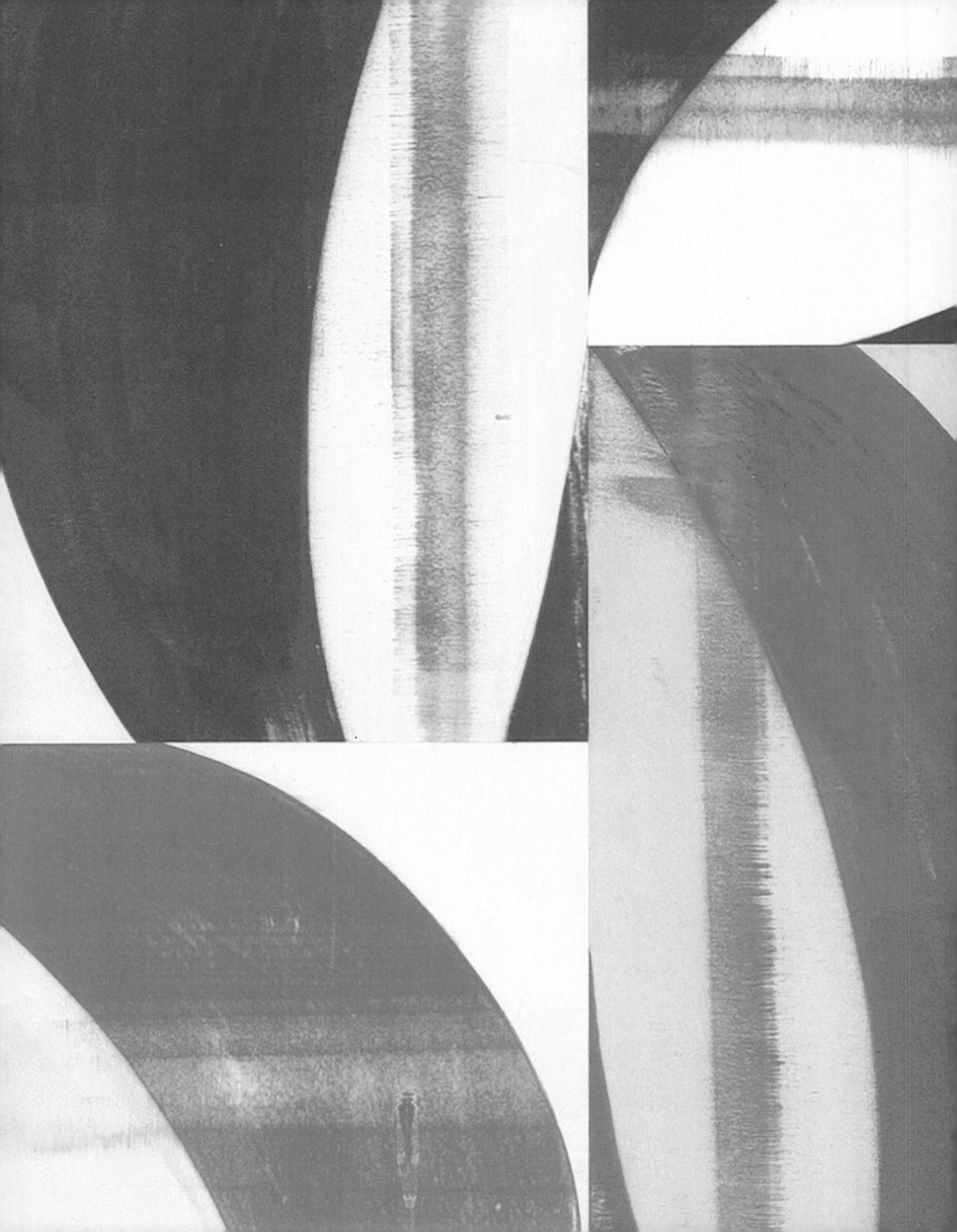

PAPER
CHARLES ARNOLDI

ESSAY BY BRUCE GUENTHER

RADIUS BOOKS

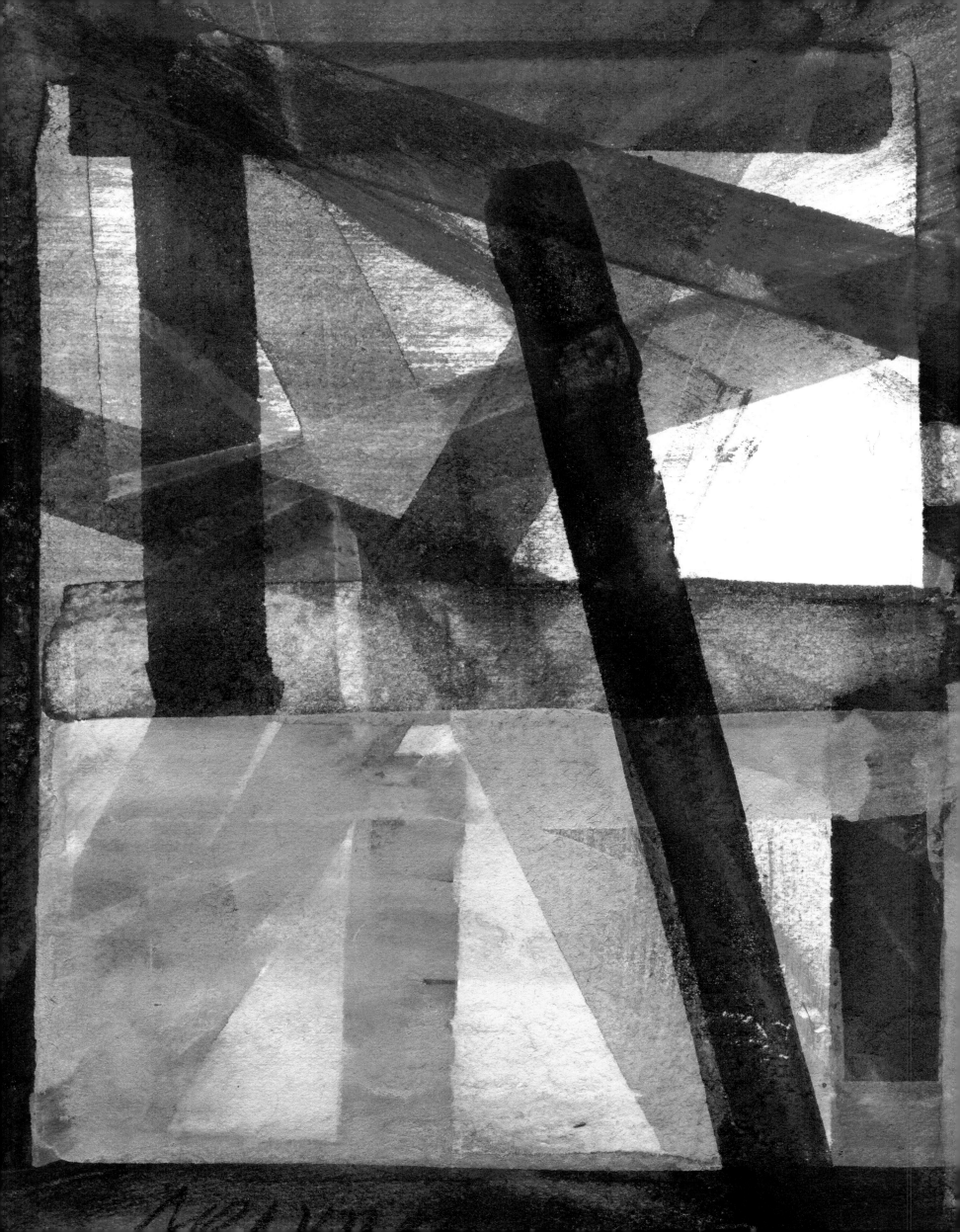

ACROSS A CAREER THAT HAS SPANNED close to fifty years, Charles Arnoldi has moved fluidly from drawing to sculpture, printmaking to painting through a practice of continuous experimentation that has audaciously challenged the limits of medium and the expectations of the viewer. Without dogma or ideology, Arnoldi has established the parameters of his investigation in the studio to discover, test, and discard through his work process a myriad of possibilities offered by a medium or motif to arrive at a moment of unqualified beauty. As Arnoldi has said of his practice, "I walk into the studio, set up a problem, and then I solve it. The integrity of the work is built from that process—the struggle—and my belief in the vulnerability, honesty of abstraction." It is in his dogged commitment to the search and its resolution that Arnoldi has created a singular oeuvre of innovation and aesthetic pleasure.

Drawing has been at the core of Arnoldi's work since the late 1960s, when the Ohio native established his first studio in Los Angeles. A natural draftsman, he has used drawing and subverted the full spectrum of drawing's concentration of essentials and its traditional uses—the quick notation of something seen—as a tool to learn the structure of form, explore a new idea, or as a study for a larger work, as well as an independent finished work of art. He has benefited from and exploited the changing nature of drawing in the mid-twentieth century when drawing as an art form was no longer defined by the means or size of the work and came to parallel the fast-evolving issues in painting. Following on the surrealists' use of drawing to reveal the conscious and unconscious mind, the American abstract expressionists' expanded the vocabulary of drawing from pencil and charcoal to paint-loaded brushes, and introduced the methods and aims of drawing into their paintings.

Artists as diverse as Willem de Kooning, Franz Kline, Arshile Gorky, and Robert Motherwell moved the drawn/painted line to the very core of their painting practice. With his dripped, thrown, and trailed lines of paint, Jackson Pollock freed line from description and color from decoration to make works of immediate perceptual experience that fused drawing and painting. Their collective activity, through the direct expression of creative process and materials, gave drawing a new primacy in mid-century art. Charles Arnoldi embraced this expanded aesthetic terrain of drawing and through it established his intellectual independence in Los Angeles's highly experimental art scene of the late 1960s and 1970s. Through a radical departure in materials, he made drawing physical and revolutionary in an art scene awash in rule-breaking materials and activities.

Coming of age at a moment when traditional painting and the notion of the masterpiece were under critical attack by Minimalism and the theories of postmodernism, Arnoldi began to use wood twigs and branches to make dimensional drawings in space. Moving from his earlier simple painted wood sculptures, he rapidly developed a brilliant hybrid form of sculptural drawing that created a confluence of lines-on-paper and branches-in-space that physically occupied the place of painting on the wall. Not unlike the free-hanging string and resin constructs of Eva Hesse at the same moment on the East Coast, Arnoldi's works fundamentally redefined the parameters of drawing and the vocabulary of sculpture in this congruence of the described line and actual manipulated wood branches. The *Stick* works were both an artistic innovation that has had a continuing influence on artists today and elegant works of inspiring aesthetic pleasure.

The *Stick* works were assembled on the studio floor from branches Arnoldi gathered in the woods, which he stripped of their bark and extraneous offshoots in order to clarify the "found" line he could see in them. Loosely based on a grid system, the work's wood branches were then cut and fitted into a layered web of lines that when hung up projected off the wall, creating an actual linear drawing in space and a flat shadow drawing on the wall. The surface of the large *Stick* wall drawings varied over time from natural wood to painted surfaces that defined a particular branch or served to call attention to the front/back relationships of the structure, and on occasion covered the entire work in an eye-challenging carnival of bright hues. When Arnoldi made conventional paper-based drawings in this period, they were often small scale and intended to serve as tools to explore or record the structure of a larger wood-based work. Rendered in a variety of mediums from pencil to watercolor and gouache, the works set up a mimetic relationship to the wood branches rendered in single, parallel, or watercolor lines. The literalness of these drawings is immediately apparent as a description of the boundaries and connections that define the form and internal spatial construction of the *Stick* works. Where the actual branches are visually contained by the limits of the physical structure, the layered web of lines on the paper are contained by the margins of the sheet and activate its entire surface as a part of the composition. As would be his practice going forward, Arnoldi used whatever medium was at hand to invent and activate a gestural linearity in the works as a syntactic language of abstraction.

By the mid-1970s, Arnoldi's wall-hung *Stick* drawings had evolved from dimensional, open, linear structures into a denser multilayered screen of straight sticks that was becoming a rich mixed-media painting form, and eventually a group of oil and acrylic on canvas paintings of sticks. Likewise, his drawing practice had moved from a recording and task-oriented activity to a parallel,

independent activity. The drawings associated with this second phase of Arnoldi's *Stick* works are characterized by a fresh spontaneity in the drawn line that builds complex new linear rhythms from irregular networks of diagonal bars laid down by the artist. A series of graphite drawings from 1975–76 illuminates his method of organizing the sequences of increasingly physical marks into open, dynamic vertical structures that are stacked in successive layers. A master of materials, Arnoldi harnesses graphite's range of marks from glossy solidity to dusty blush in his search for the right balance between structure and gesture on the sheet. The fields of tilting, pitching lines that transform the empty sheet into a specific space are further worked through wiping, washing, and the mechanical erasing of lines to enrich both the spatial complexity and variability of the drawn lines. The resulting pentimento of erased and washed lines both enriches the physicality of the paper surface and highlights the tonal range from absolute black to faint gray penumbra in these drawings. Visually entering these works, one's eye is teased across the sharply drawn surface to penetrate the densest thickets of lines to ferret out shadowy passages and hollows. It is an imaginative journey that elicits an intense pleasure and brings a deep satisfaction to the mind of the engaged viewer.

Arnoldi fully exploits the configurations of chance in his work of the 1970s. Scattering marks across the paper, he begins to collect and edit the initial compulsive linear strokes into intervals and precarious masses of line, opening and closing emergent grids spatially. In the process of tracing, erasing, and retracing lines on the drawing sheet, the artist is driven to find a visual necessity for every mark. The act of creating carries him further onto a plane of the imagination where he acts—neither totally submerged in the process nor a dispassionate editor completely outside of it. As an example, an 1978 untitled oval pastel and graphite drawing [PLATE 16] is built through

such a process, with layer upon layer of colored bars—drawn and redrawn—that ultimately come to fill every bit of space in a crosshatchlike pattern of ebullient color. It is clearly a drawing that results from the act of making a work rather than creating a specific image, the artist starting, finding, refinding satisfaction in absolute abstraction.

In 1980, film footage and photographs of the aftermath of the volcanic eruption of Mount Saint Helens in the state of Washington precipitated another important shift in Arnoldi's work. The images of the estimated four billion board feet of timber thrown and piled into the valleys and logjams across the path of the eruption's devastation inspired Arnoldi to begin a new series of work that reintroduced actual sticks in combination with painting. His post-eruption drawings become even denser and clotted with sticks/bars in fluid, directional arrangements that overlay and collide across the paper. The balanced, overall distribution of marks in the late 1970s drawings now gives way to disequilibrium of marks in the drawings of the early 1980s. As the decade progresses, a series of flat shapes are introduced into the drawings as stable counterpoints to the increasingly jagged linear marks of the works. These motifs are clearly an outgrowth of the second deeply radical break Arnoldi made with accepted artistic practices and materials in painting. Seeking greater mass and physicality for his work, he begins to laminate multiple layers of plywood sheets together as a ground on which to build a surface of paint and line, which he then cuts with a chainsaw. Moving back and forth from paint-brush to chainsaw, he shapes the painterly illusion of space chromatically and reshapes the physical edges and face of the work. In a dangerous and often bravura performance, Arnoldi aggressively used the chainsaw to draw, mark, and disrupt the work as a way to build a richly physical opticality of color and mark that is at once both primitive and sophisticated. To this day, the works have a riveting presence on the wall and elicit an electrifying thrill.

Spontaneous and improvisational as the *Chainsaw* paintings are for the viewer, there are a number of small drawing studies for these works that show the artist considering overall composition, perimeter edge configurations, and the addition of cutout pieces of the laminated ground back onto the surface of the large paintings. The 1989 untitled sketch for a large, four-panel *Chainsaw* painting [PLATE 31] delineates the artist's plan for a series of cutouts, directional indicators for linear cuts on the surface, the appliqué of bark or plywood slabs and trunklike sticks. The drawing imparts the immediacy of invention and the intimacy of the artist's hand at work on the page. The jagged shapes of the plywood cutouts and irregular perimeters of the *Chainsaw* paintings provide new motifs for the artist's drawing vocabulary. During this period, these new shapes served as angular blocks of floating color or structural elements in the spatial compositions of both his drawings, and for a series of large rule-breaking monoprints using plywood matrix executed with master printer Richard Tullis at the Garner Tullis Workshop, Santa Barbara, California.

In contrast with the very physical nature of his studio practice at various points in time, drawing has been a seated activity at a table or desk for Arnoldi, which accounts for the relatively modest scale of much of his works on paper. Some part of every day finds him at work in a notebook or sketchpad: thinking through the graphite in his moving hand about a familiar motif, sketching the first blush of a new idea, or pushing toward a fully realized work of art. It is a reflective activity that allows him to absorb, inventory, and expand on his continuous experimentation with materials and process in the studio. A happily compulsive worker, Arnoldi is never without a sketchbook and materials when he travels—the travel drawings are inscribed with the place where they were created. When his two children were born at the end of the 1980s, Arnoldi agreed to a family "Sunday Rule", which meant staying home from the studio and allowed

for more drawing time "with the family," which resulted in the children's crayons becoming part of his drawing materials [PLATES 26, 32].

The end of the 1980s was also marked by a period of questioning and introspection for Arnoldi when within six months he suffered the loss of his brother to AIDS and the death of his mother. The loss and anger connected to those deaths coupled with the pressures of family, a successful career, and the expense of maintaining a large studio operation caused him to radically redefine his practice. He put down the chainsaw in deference to his young family, eliminated much of the superstructure of the studio operation, and stepped away from any work that required assistants.

Turning his back on all of that, Arnoldi went into unexplored territory as he picked up a brush to go back to painting and drawing. And like Pollock before him, Arnoldi's use of the brush allowed the form and materiality of his work to merge across media, and especially in the realm of drawing where the means of traditional drawing—pencil, charcoal, and pastels—mingles with painting's oil, acrylic, and gouache in exciting new surfaces and mark-making activity. In an untitled 1989 ink drawing [PLATE 32] the rapid broken black lines mass together in sharp vertical and horizontal clusters that stop the eye and create a forbidding, discordant space. The drawing's uncharacteristically affective quality became part of some of the new paintings that began to fill the quiet studio.

In this process of renewal, he began with a single continuous line—following the painted or drawn line, tracking it across the field, anxiously wiping it away and redrawing it—to make work that was anticipatory and urgently affective at one moment, and meandering and luxuriously languid at another. Using gouache for many of the drawings made during this time, Arnoldi would build an incident-rich field by drawing and redrawing

lines, washing the paper, and drawing again, repeating the process until the surface carried the visual memory of the searching movements of his brush and was ready for a final scrim of line, confident and exultant [PLATE 36]. As the work of redefining his practice progressed, Arnoldi's simple dictum to "follow a line" to germinate form and structure gained in assurance and complexity as it coursed, folded, and swelled over itself in drawings and paintings.

The decision to build a house in Hawaii in 1990 and spend time in the exotic landscape of the islands presented a new source of formal inspiration for Arnoldi. Inspired by the saturated colors and silhouettes of the tropical foliage, he filled notebooks with drawings of fragments of leaves, linear silhouettes, swatches of color and texture [PLATE 28], embarking on his first extended foray into a nonlinear formal vocabulary. The looping curvilinear line of his work readily morphed into a series of playful, flat biomorphic motifs that suggested both the multi-lobed leaves of the philodendron and a space-age modernism. Layering these malleable, evocative motifs onto a sheet alive with the effusive overlays of opaque and transparent hues resulted in works balanced between spontaneity and deliberation, hedonism and self-restraint [PLATES 29, 30]. Bright with an internal light and indeterminate space, the Hawaiian-inspired works on paper or canvas are vital, spontaneous compositions of advancing and receding planes of luscious color and animated forms.

The late 1990s into the present have been marked by an almost continuous succession of new bodies of work as Arnoldi defines the parameters of his painting and pursues the invention and germination of novel formal vocabularies through process, chance, and his body's range of movement. Without the financial encumbrances of a large studio apparatus or material need, Arnoldi has had the freedom to find his stride in the studio, producing a prodigious number of drawings and paintings. The artist's commitment to not repeating himself has accelerated

his progress in the discovery and then exploration of an idea or motif as he works to follow his intuition to the new, which becomes the familiar that must be challenged and changed before moving on to explore the next. The post-1990 works can be seen to effectively constitute an extended series of different sub-styles as one set of ideas and motifs morphs into another in the studio through a shared core of pictorially complex patterns of form and color palette; mediated by Arnoldi's process-driven execution and highly developed formal design-based aesthetic. The formal and material separation between the artist's abstract paintings and drawings is clearly now only a matter of scale and surface as he moves freely from paper to canvas and back.

Leaving the saturated fields of color in the ebullient Hawaiian works, Arnoldi employed a stark chromatic shift as part of his formal strategy in a series of works inspired by the bulbous shape of the common potato. On canvas and drawing sheets alike, he focuses on the isolated potato shape through line and the stained and clotted impasto of pigments of a monochromatic palette of sooty blacks, impure grays, and stained whites. Silhouetted, the simplified potato/oval, either singly or *en masse*, proves a potent motif in the work's scale and surface treatment. Painted or drawn, the coexisting simplicity of form with ever- greater complexity of color—ranging from opaque black, translucent streaked grays, sulfurous yellows to the ghostlike white edges of partially washed away ovals— reveals Arnoldi's painterly confidence and facility in using materials [PLATES 45–52]. Introducing a single color like red and related hues in 1999 to replace black in the series [PLATE 48] gave new impact to the imagery, and suggested the beginnings of the migration and evolution of the oval form in his work.

Beginning in 2000, the *Ellipses* series reintroduced a full palette of luminous transparent and opaque colors with a new motif, an oval contained inside a rectangle that was a further simplification and formalization of the preceding potato-inspired imagery. The drawings associated with this series introduce collage as a new working methodology in Arnoldi's exploration of the geometric orthodoxy of oval/rectangle, circle/square [PLATES 53–60]. With a basic module established, he immediately began to modify the modularity of units—different sized blocks, color combinations, stretching or truncating the ovals—to test the space/form perception of various shapes and color combinations. The drawings are composed then assembled from various sized, pre-painted two-color cards each containing a partial or truncated ellipse in a rectangle, and affixed together edge-to-edge. It is the growing complexity of the chromatic interactions of saturated color with the optical tensions between open and closed forms and of intersecting geometries of adjoining blocks that gives the *Ellipses* drawings and paintings their mysterious beauty and success.

As has been his practice from the beginning, drawing was also the vehicle for resolving compositions in the series paintings. A pencil and pastel on vellum drawing [PLATE 59] is a beautiful example of how Arnoldi has used drawing to conceive complex interlocking geometries, scale shifts, and found orders of space for large, multi-canvas *Ellipses* paintings. The use of a configuration of multiple, joined canvases as his painting format for this body of work would also serve as the solution for creating paintings and commissioned works too large for the artist to handle and move alone. He also used the variously sized canvas or painted paper modules as the compositional tool for the series of architecturally inspired works in the *Grids* and *Windows* series that followed the *Ellipses*. It is interesting to note that Arnoldi continues to use pre-painted sheets of color with or without marks as collage material for drawings associated with subsequent series.

Arnoldi upends the tight geometric structuring of the last decade in the mid-aughts with the *Arc* series, in which the introduction of a visually dynamic, shallow arcing oval takes the place of the static ellipses inside the stacked rectangles of the composition [PLATES 64–72]. Breaking apart the initial

hollow oval, he organizes the new module into multi-block compositions of slicing diagonals of countervailing arcs on a contrasting ground. First sketched and then drawn onto the ground, the elongated arcs and the field are hand painted by Arnoldi using brushes and squeegee-dragged pigment which creates at times an almost mechanical-feeling surface on the drawings and paintings. Unlike the *Ellipses, Grids,* or later *Windows* series whose beauty is the result of a powerful chromatic experience in a fixed rectilinear composition, the *Arcs*—whether intimate drawing or major painting— engage the eye and mind through the graphic punch of the slicing, scythelike forms and centrifugally organized compositions that seem to pull at the viewer like a vortex.

The rhythm and production of the studio has not abated as Arnoldi has entered his seventieth year. Actively experimenting with materials and process to challenge and expand the possibilities of his work, the artist moves back and forth from drawing table to painting studio daily; engaging and reflecting as a continuing stream of new work appears and then morphs into the next cycle of problems to solve, ideas to explore in the quest for that intangible quality that will trigger an intense pleasure in the eye and mind.

The relationship between what we see and what we know is never settled.[1]

John Berger's observation, above, about the nature of looking has captured something essential for me in the unmediated experience of seeing a work of art by Charles Arnoldi. Whether it is a drawing or a painting, for one to stand consciously with an Arnoldi work in the specific moment of viewing is to be wrapped in aesthetic sensation outside of any recognizable or classifiable reference. Then to catalogue what is seen tangibly in front of one is simply to recite a list of materials, colors, and dimensions without touching the sensation of seeing the work. Just as a mental review of what one knows about the artist, the period, and school of abstraction will not clarify or name the questing arousal one experiences in looking at the work. It is Arnoldi's gift, decade after decade, to create works of intense beauty that trigger the simultaneously enveloping physical relaxation and mental arousal that is the hormonal signature of beauty's animal joy. Berger understands this phenomenon and the inadequacy of the rational brain's response to its stimulators—the realization that what we tangibly know is never equal to what we see and experience through seeing. The search to create that moment in his work has been the raison d'être of Arnoldi's studio life and the underlying force in his evolving abstraction.

Drawing has been a constant source of discovery for Arnoldi in that search, and a channel for the cerebral and emotional inspiration that drives the internal logic of his art. The daily routine of drawing serves to clarify and expand the leaps of invention that emerge from Arnoldi's continuous experimentation with materials and image in the studio. Drawings are a chronicle of his journey and the audacious challenges that he has set for himself to expand the limits of media in the search for beauty; drawing reveals the visual signification and interrelation-ships of motif and idea in Arnoldi's oeuvre.

From the historic paradigm-changing *Stick* and *Chainsaw* works to the vigorous authority of the lushly worked paintings of the past decade, Charles Arnoldi has rest-lessly traveled a solitary path of creativity in his search to discover and articulate beauty. He has found that mysterious place where beauty resides, and has given us the gift of an entrance to it through his art.

— BRUCE GUENTHER

1. John Berger, *Ways of Seeing* (London: Penguin Books, 1973).

PLATES

PLATE 1 | UNTITLED, 1971 GRAPHITE ON PAPER, 8½ x 5½ INCHES

PLATE 2 | UNTITLED, 1972 GRAPHITE ON PAPER, 19 x 24 INCHES

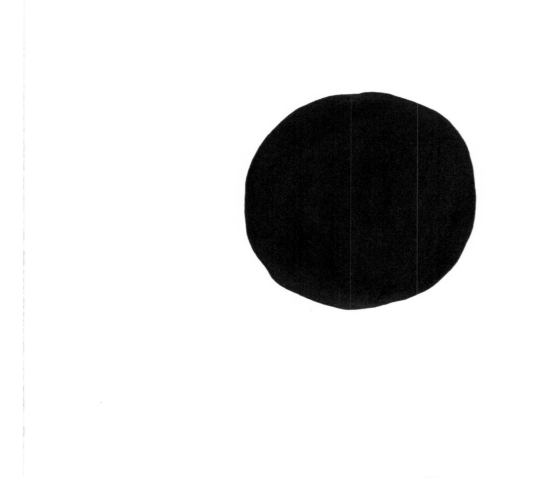

PLATE 3 | **UNTITLED, 1972** PENCIL ON PAPER, 17 x 22 INCHES

PLATE 4 | UNTITLED, 1972 INK & PENCIL, 14 x 11 INCHES

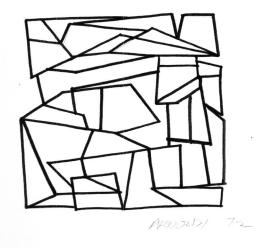

ARDSSIDI 7-2

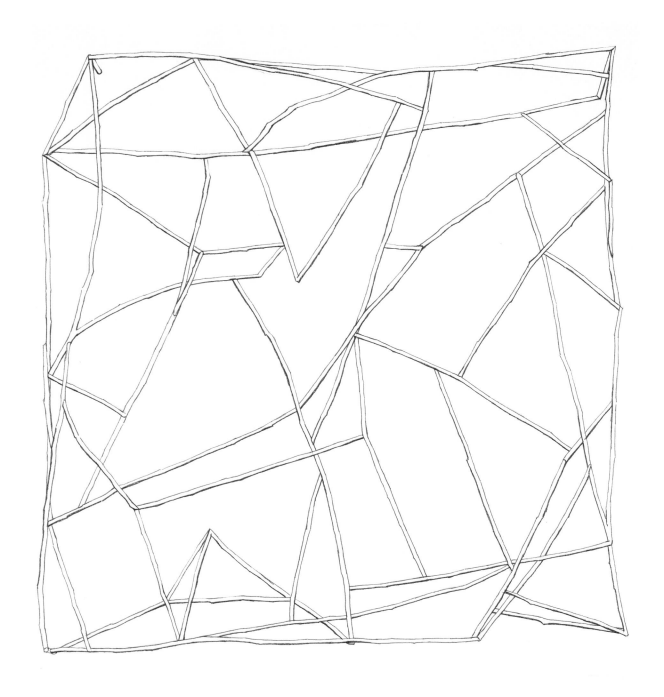

PLATE 5 | UNTITLED #3, 1974 PENCIL ON PAPER, 24¾ x 19¾ INCHES

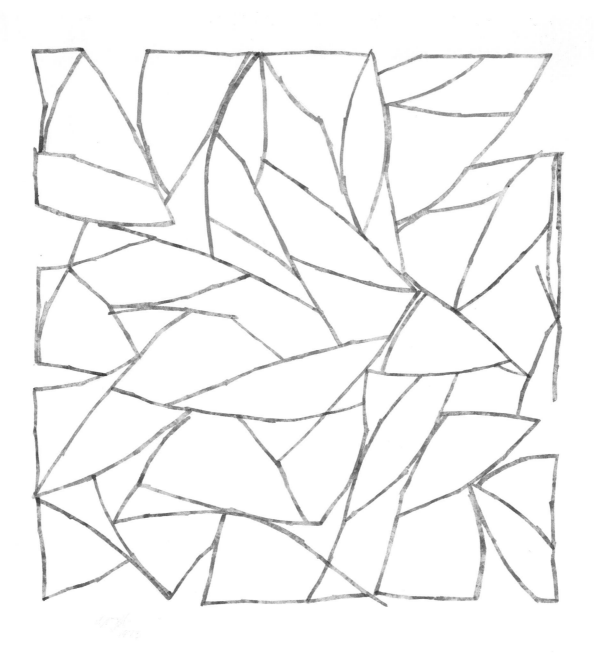

PLATE 6 | UNTITLED, 1973 GRAPHITE & WATERCOLOR ON PAPER, 22½ x 21½ INCHES

PLATE 7 | **UNTITLED, 1971** PENCIL ON PAPER, 22 x 17 INCHES

PLATE 8 | **UNTITLED, 1972** GOUACHE ON PAPER, 22 × 30 INCHES

 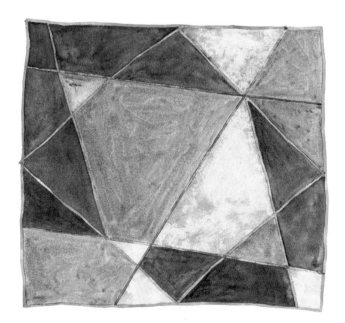

PLATE 9 | **UNTITLED, 1975** PASTEL & GRAPHITE ON PAPER, 29 x 23 INCHES

FOLLOWING PAGES:

PLATE 10 | **UNTITLED, 1975** GRAPHITE PENCIL ON PAPER, 29 x 23 INCHES

PLATE 11 | **UNTITLED, 1975** GRAPHITE PENCIL ON PAPER, 29 x 23 INCHES

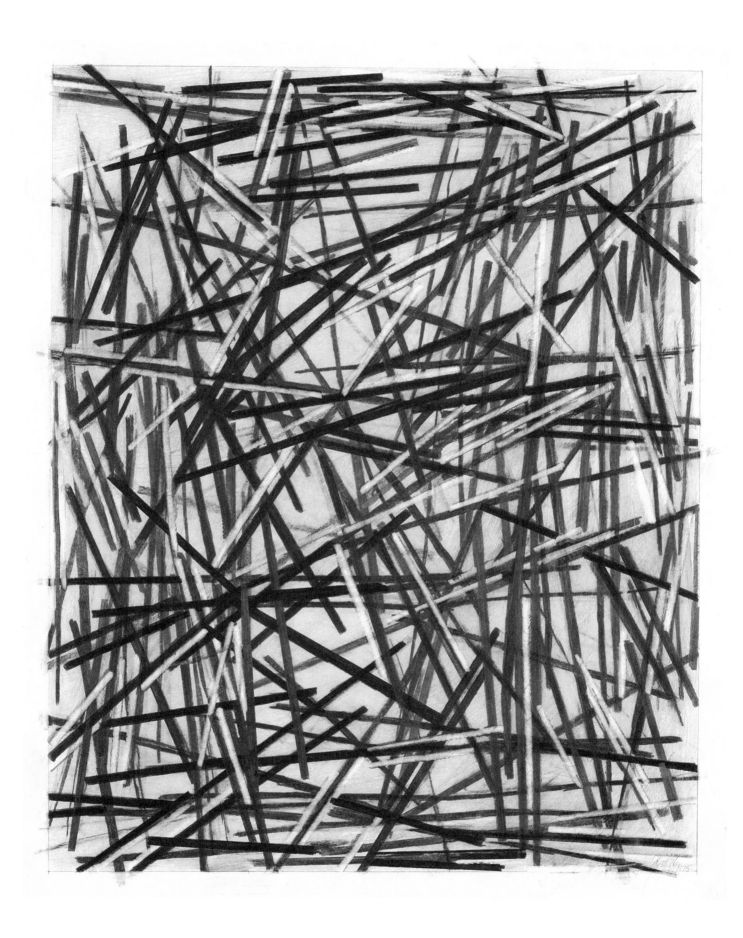

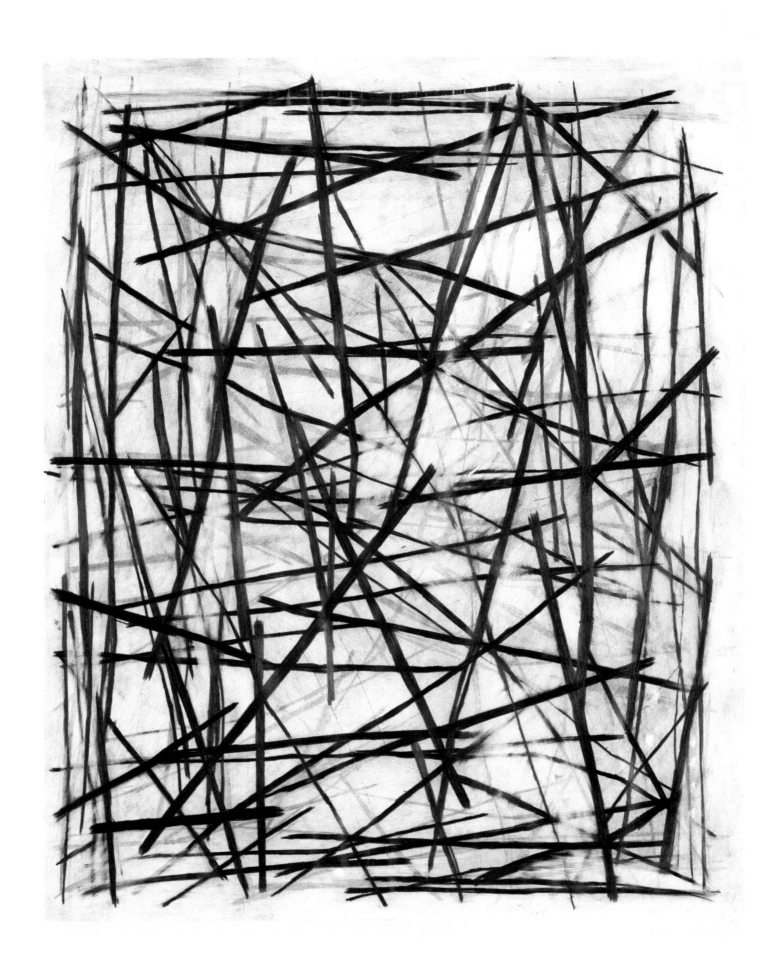

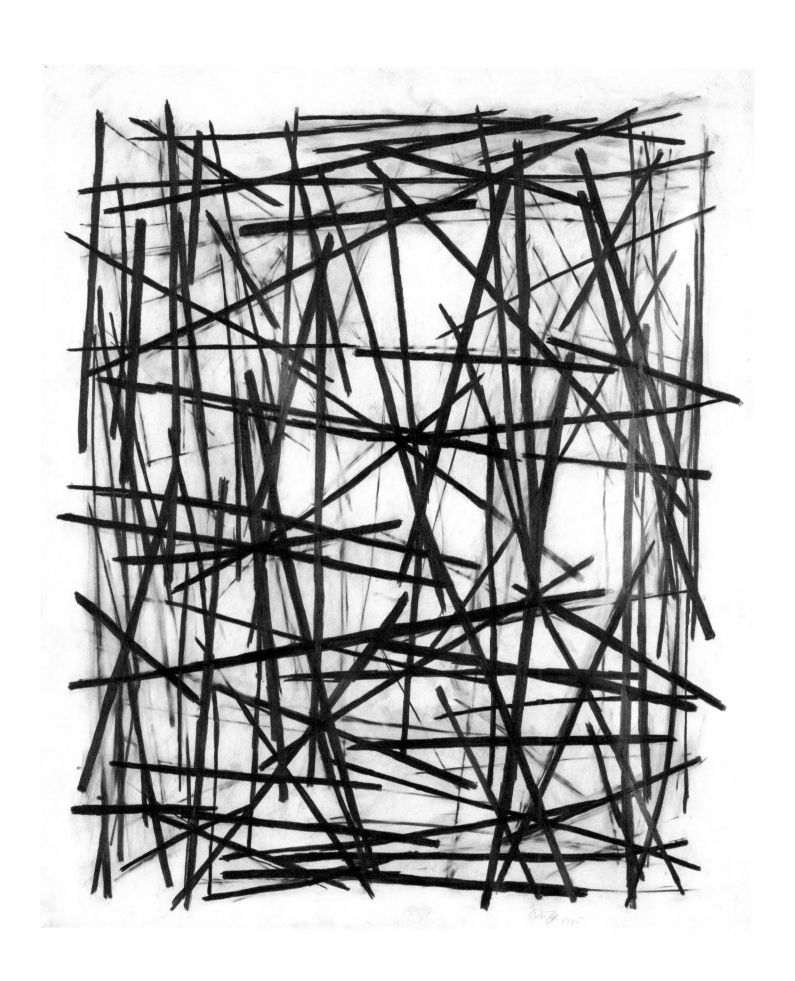

PLATE 12 | **UNTITLED, 1975** INK ON PAPER, 14¼ x 11¼ INCHES

PLATE 13 | **UNTITLED, 1974** PENCIL ON PAPER, 24 x 19 INCHES

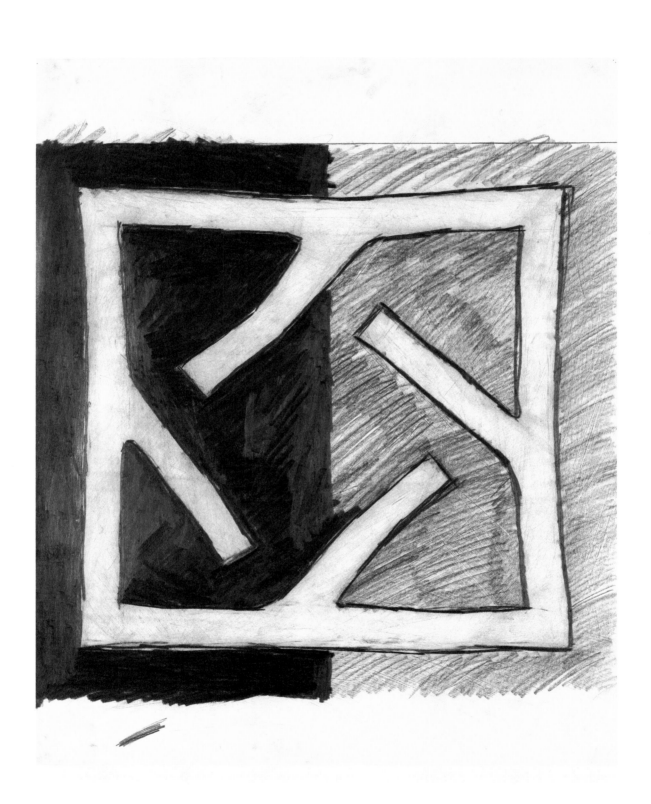

#375.00

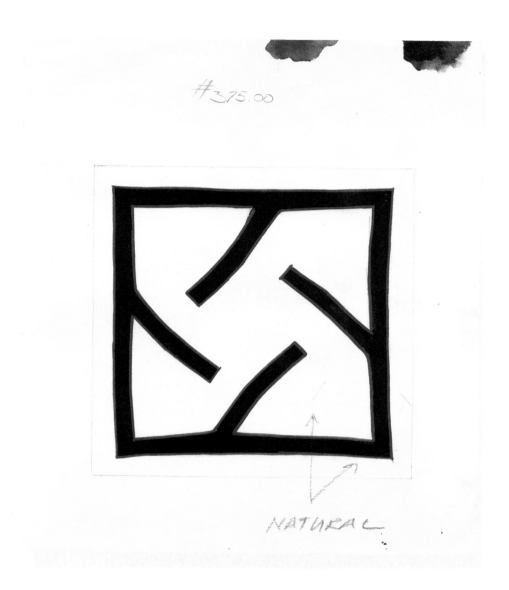

NATURAL

PLATE 14 | UNTITLED, 1975 GOUACHE & PENCIL ON PAPER, 10 x 8½ INCHES

$375.00

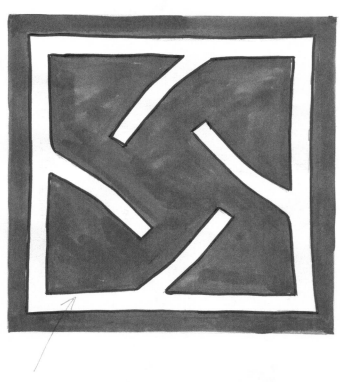

NATURAL

PLATE 15 | UNTITLED, 1975 GOUACHE & PENCIL ON PAPER, 9 x 8 INCHES

PLATE 16 | **UNTITLED, 1978** PASTEL & GRAPHITE ON PAPER, 15½ x 11 INCHES

PAGES 36–37:

PLATE 17 | **UNTITLED, 1979** OIL PASTEL ON PAPER, 27¼ x 21½ INCHES

PLATE 18 | **UNTITLED, 1979** OIL PASTEL ON PAPER, 27½ x 21⅜ INCHES

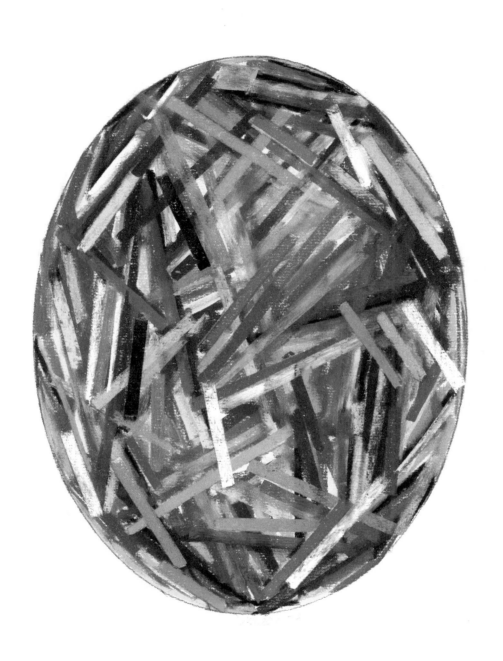

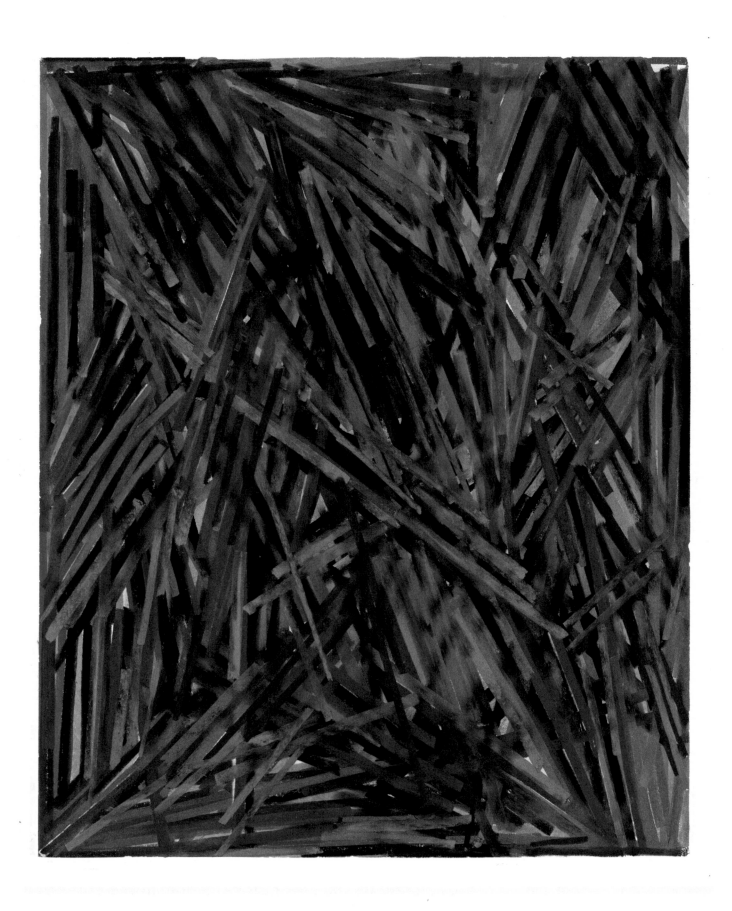

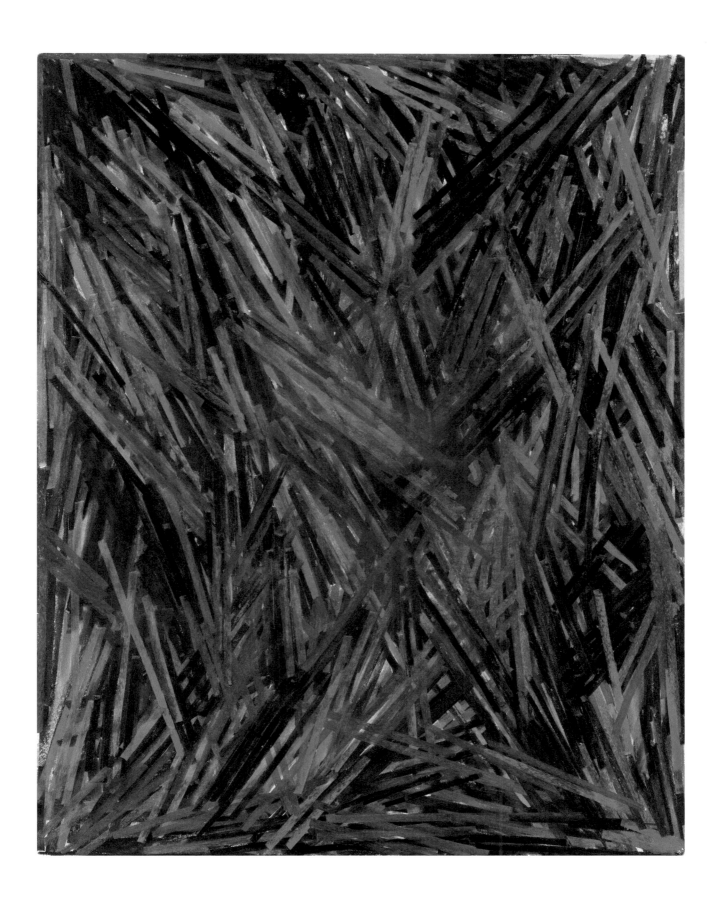

PLATE 19 | UNTITLED #3, 1974 PENCIL ON PAPER, 11 x 8½ INCHES

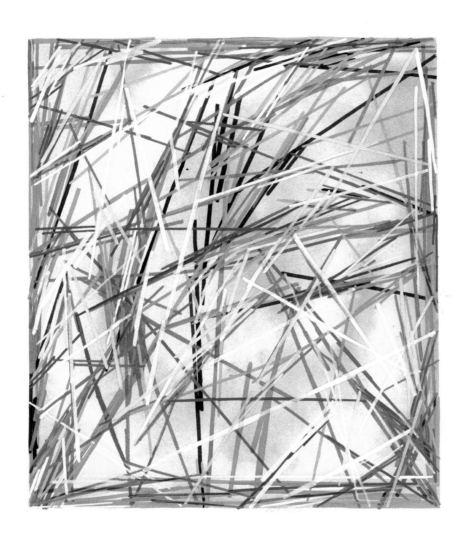

PLATE 20 | **UNTITLED, 1982** GOUACHE ON PAPER, 7 x 5 INCHES

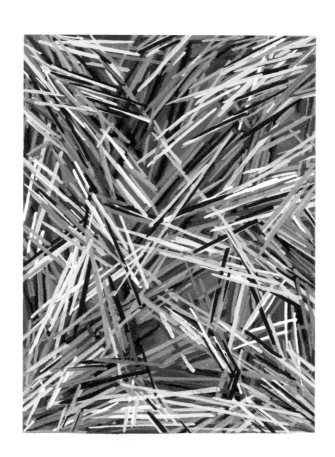

PLATE 21 | UNTITLED, 1984 INK ON PAPER, 8 x 5 INCHES

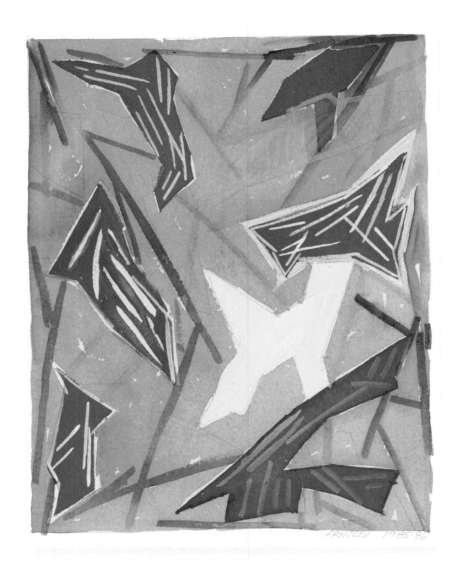

PLATE 22 | UNTITLED, 1985–86 GOUACHE ON PAPER, 9 x 7 INCHES

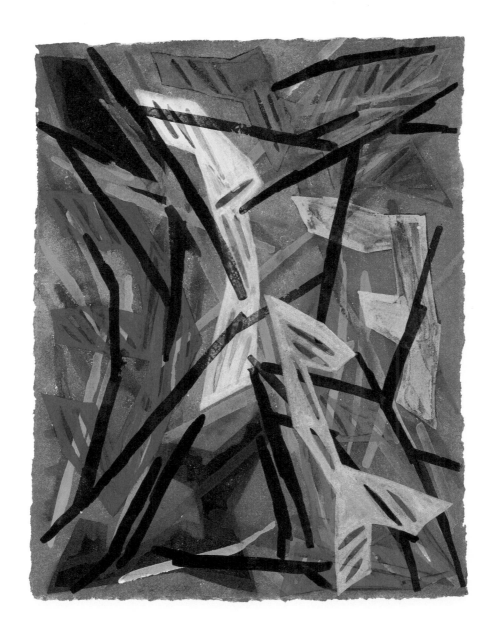

PLATE 23 | UNTITLED (ZIHUATANEJO MEXICO), 1987 GOUACHE ON GRAY PAPER, 12⅝ x 9½ INCHES

PLATE 24 | **UNTITLED, 1986** GOUACHE ON PAPER, 9 x 6 INCHES

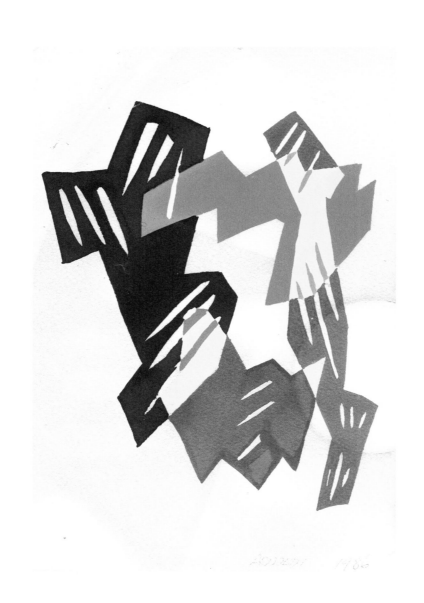

PLATE 25 | **UNTITLED, 1988** GOUACHE ON PAPER, 13 x 10 INCHES

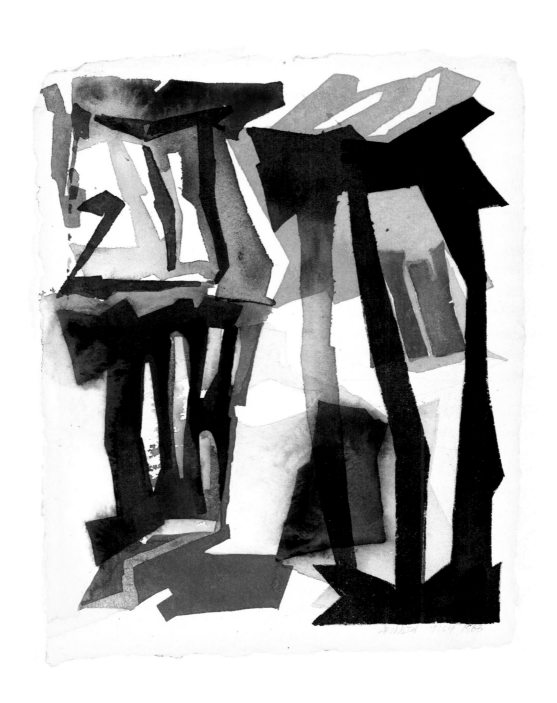

PLATE 26 | **UNTITLED, 1988** WET CRAYON ON PAPER, 6 x 10½ INCHES

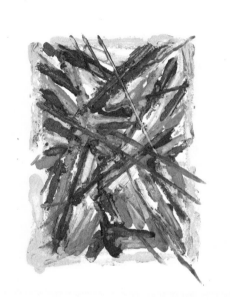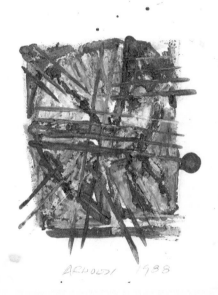

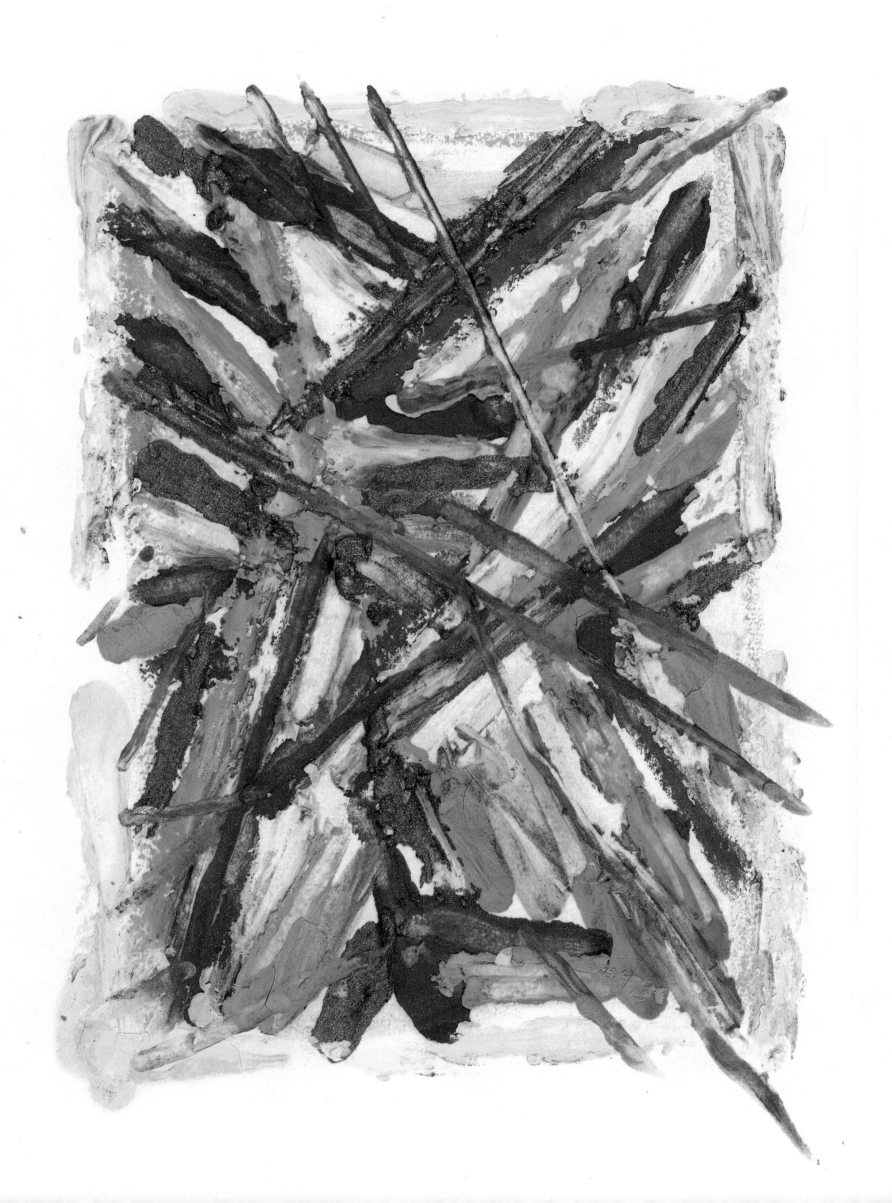

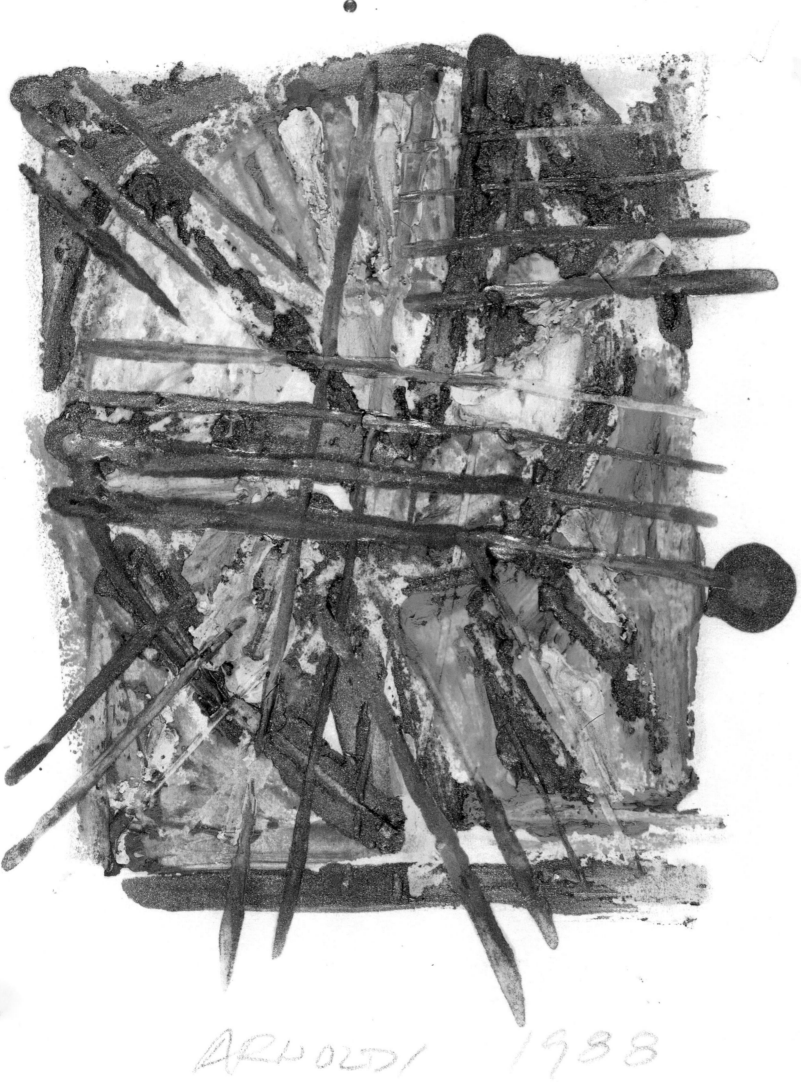

ARNOLDI 1988

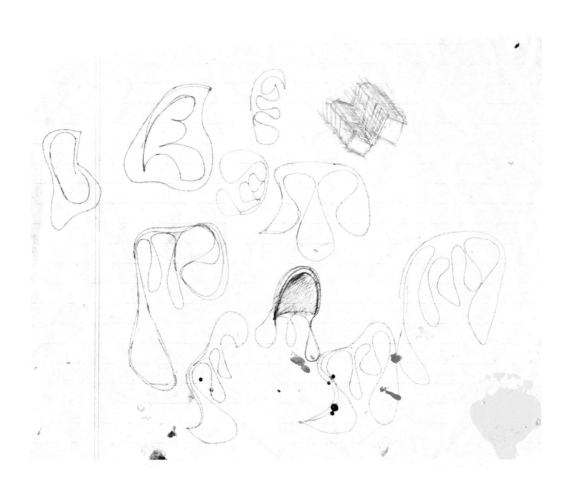

PLATE 28 | **UNTITLED, 1988** PENCIL, INK & GOUACHE ON PAPER, 6 x 4 INCHES EACH

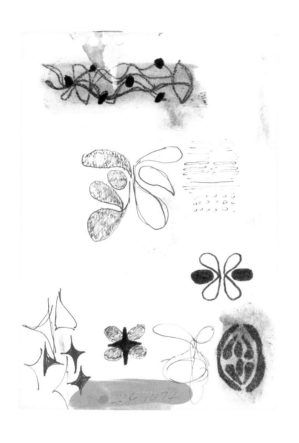

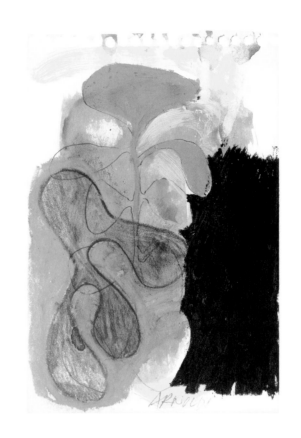

PLATE 29 | UNTITLED, 1988 INK ON GOUACHE, 6 x 4 INCHES

PLATE 30 | UNTITLED, 1989 INK ON PAPER, 6½ × 5 INCHES

PLATE 31 | UNTITLED, 1989 PENCIL, INK & GOUACHE ON PAPER, 8 x 10 INCHES

SPLINTEREY COLLAGE
CUBISM

BARK SPOTS
STICKS

BARK SPOTS
MODELING PASTE

SPLINTERED WOOD
LARGE CUT OUTS

HOLES

8

DOUBLE THICK SINGLE SINGLE DOUBLE

12

SPLINE
CRIMSON
BRK SPOT
STICKS

8

DOUBLE THICK
SINGLE

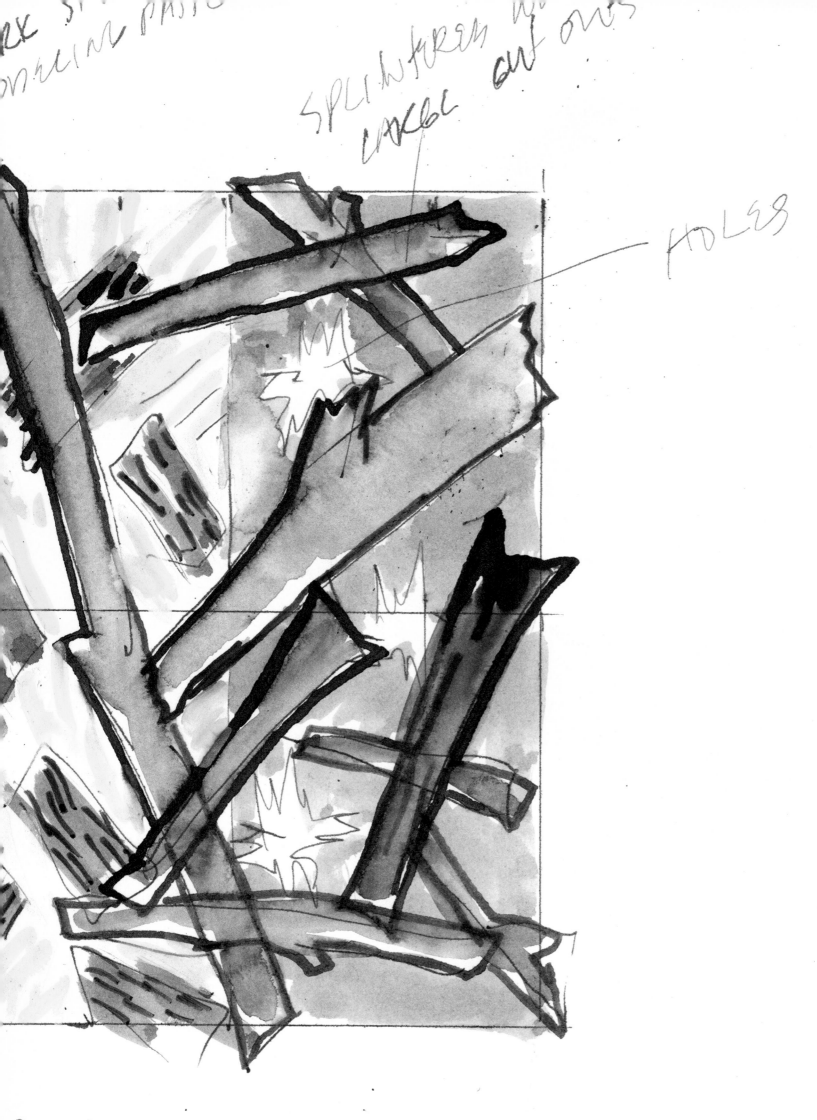

PLATE 32 | **UNTITLED 10, 1989** WAX CRAYON ON PAPER, 6⅞ x 5⅝ INCHES

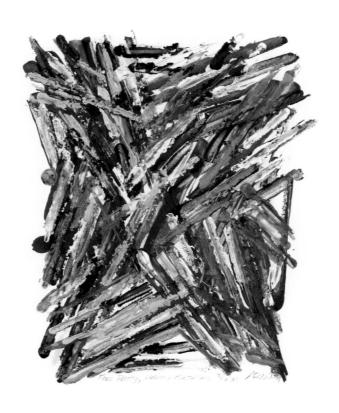

PLATE 33 | **UNTITLED, 1989** INK ON PAPER, 6 x 4 INCHES

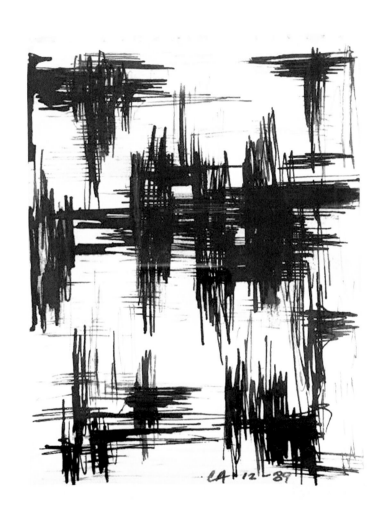

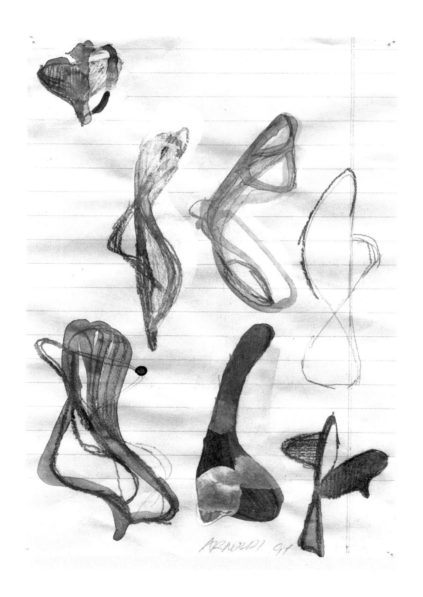

PLATE 34 | UNTITLED, 1991 GOUACHE & PENCIL ON PAPER, 7¼ x 5 INCHES

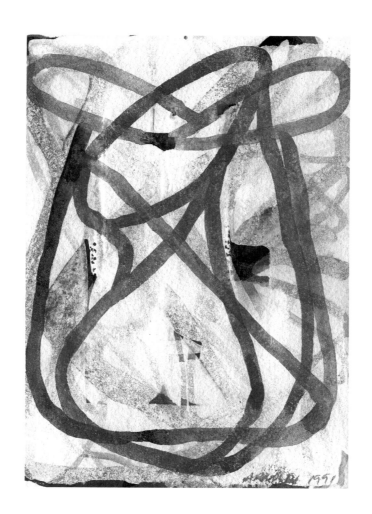

PLATE 35 | UNTITLED, 1991 GOUACHE ON PAPER, 5¾ x 4⅛ INCHES

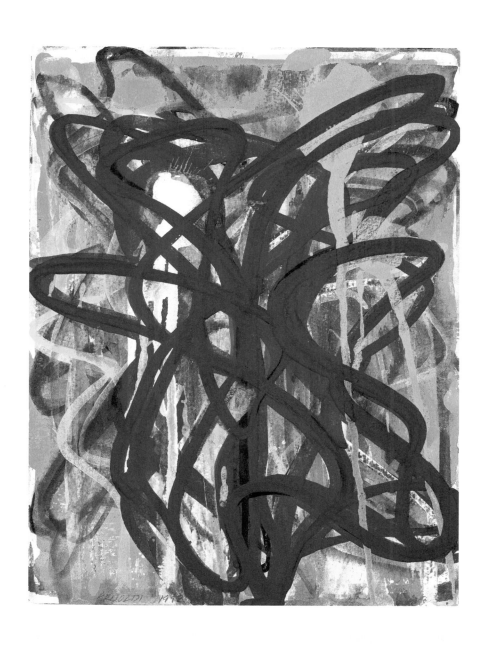

PLATE 37 | **UNTITLED, 1991** GOUACHE ON PAPER, 8 x 6½ INCHES

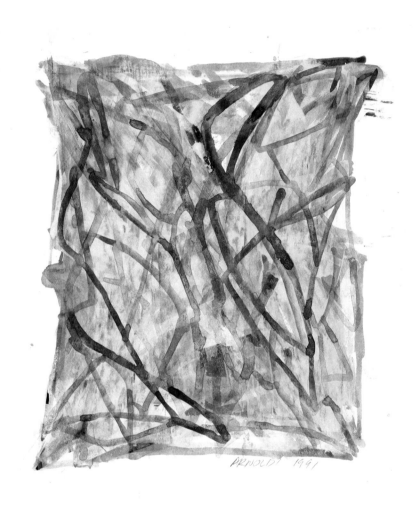

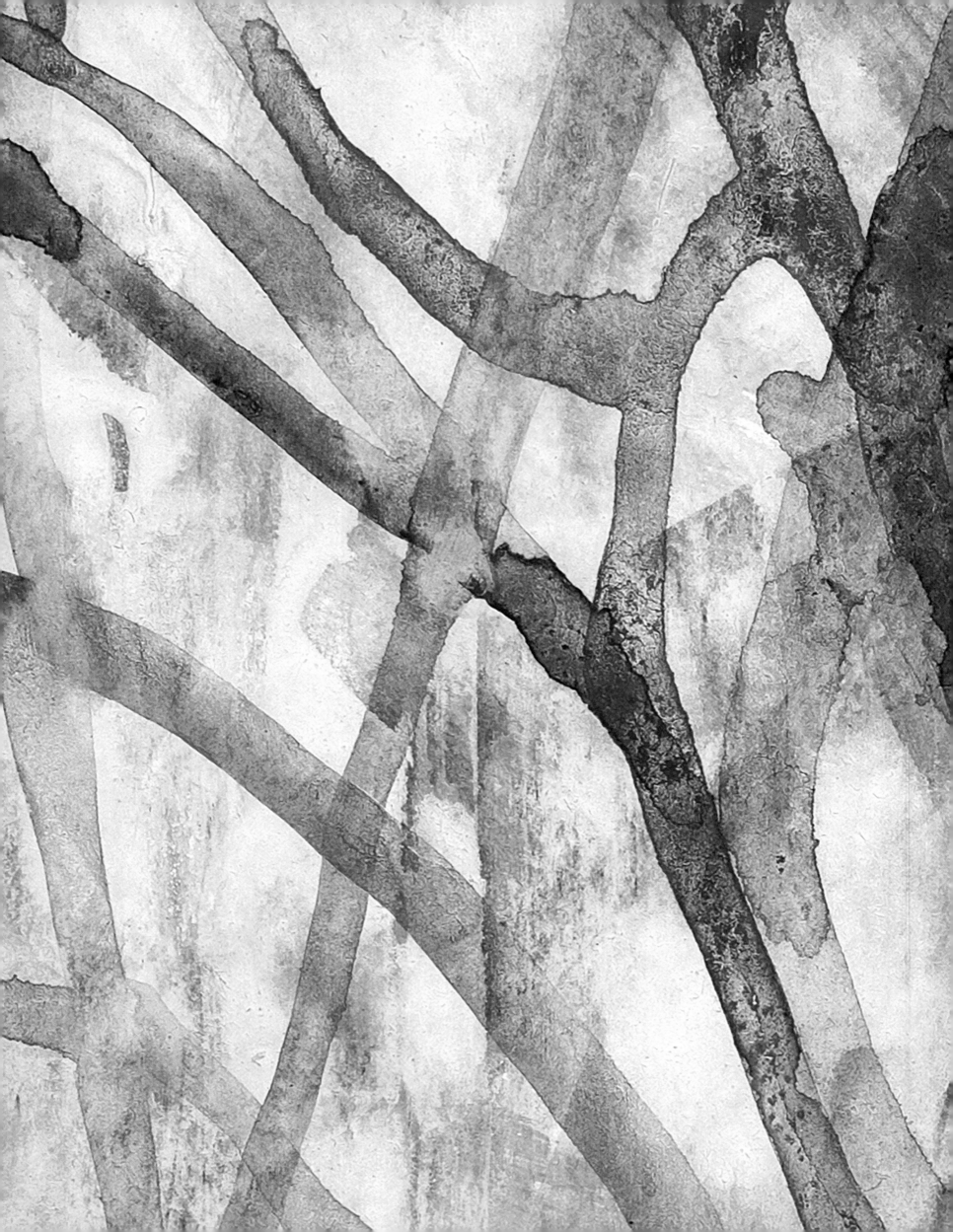

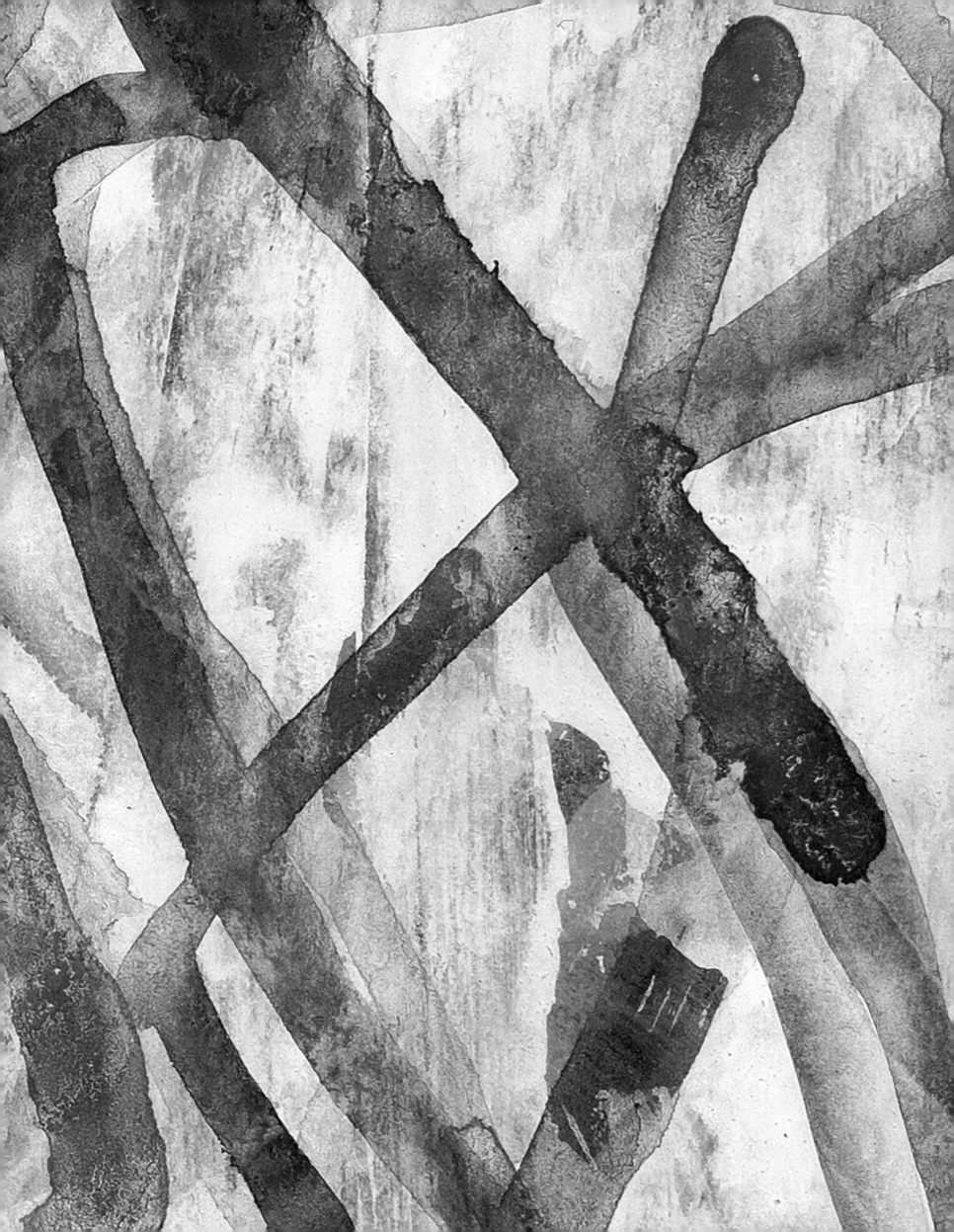

PLATE 38 | UNTITLED, 1991 PENCIL, INK & GOUACHE, 7½ x 5 INCHES

2 FORK HIGHWAY

PLATE 39 | UNTITLED, 1991 INK & PENCIL, 6 x 4 INCHES

PLATE 40 | **UNTITLED, 1994** GOUACHE ON PAPER, 5¾ x 4⅛ INCHES

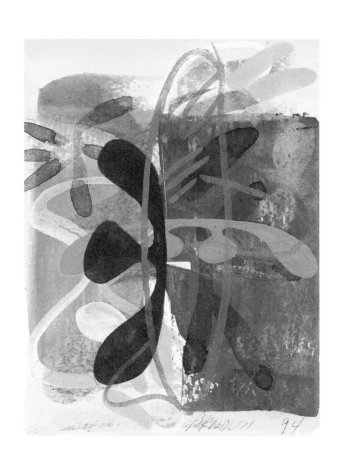

PLATE 41 | UNTITLED, 1995 GOUACHE ON POSTCARD, 5¾ x 4⅛ INCHES

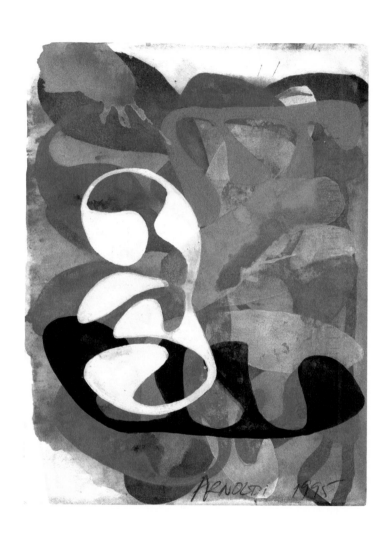

PLATE 42 | **UNTITLED, 1997** GOUACHE ON PAPER, 7 x 10 INCHES

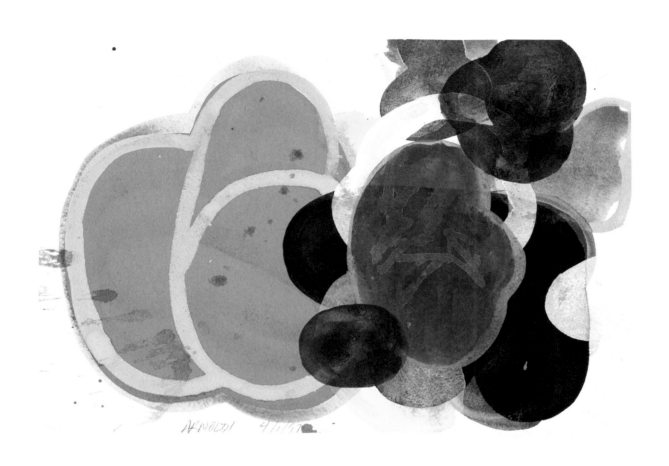

PLATE 43 | **UNTITLED, 1997** GOUACHE ON PAPER, 10¼ x 7⅛ INCHES

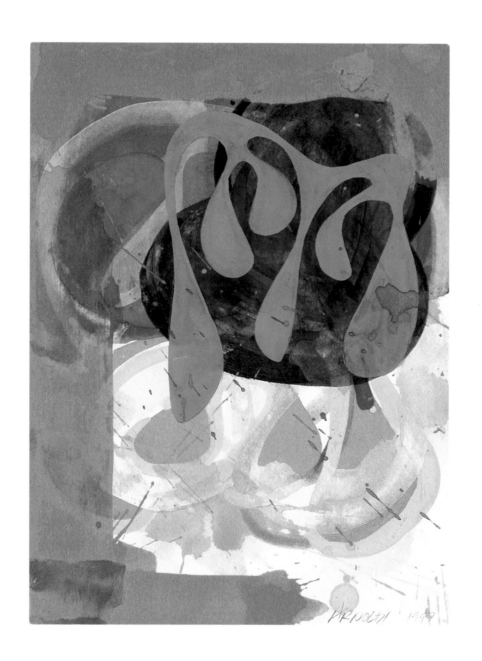

PLATE 44 | **UNTITLED, 1997** CHARCOAL, GOUACHE & PENCIL ON PAPER, 12 x 9 INCHES

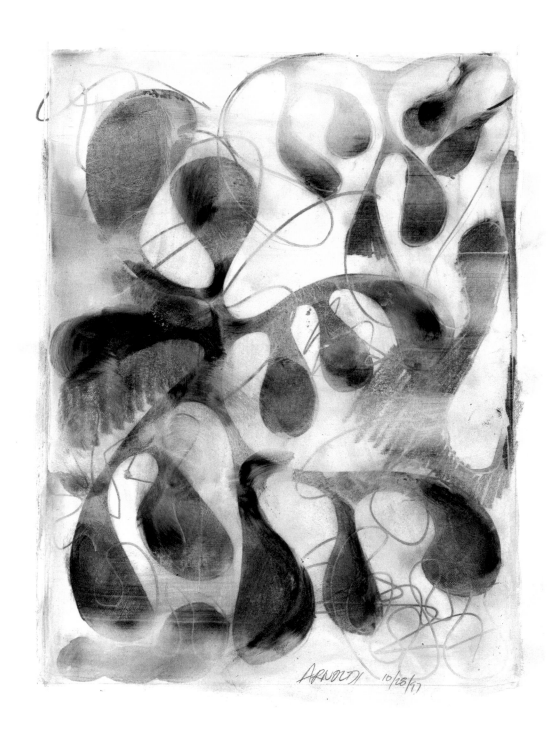

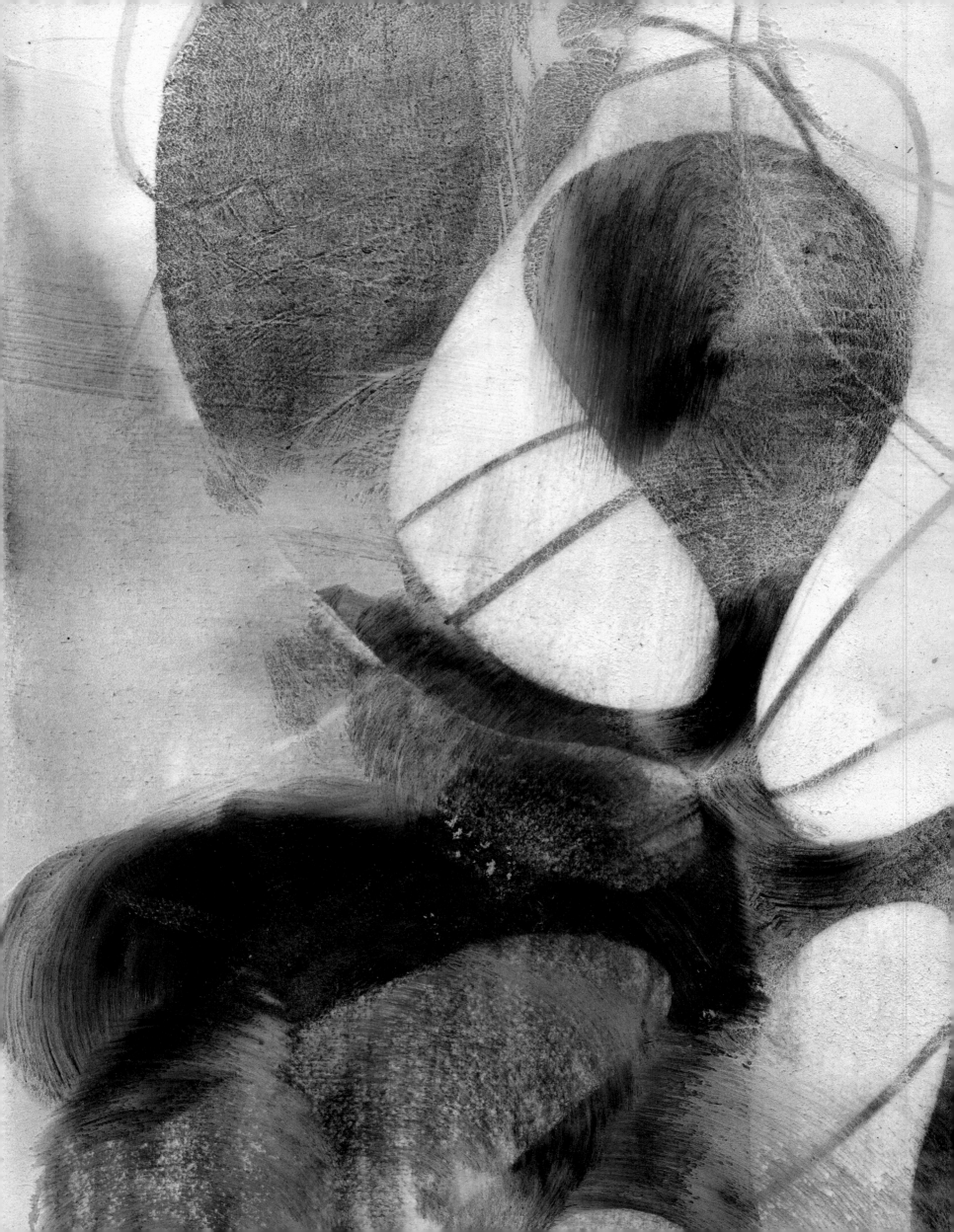

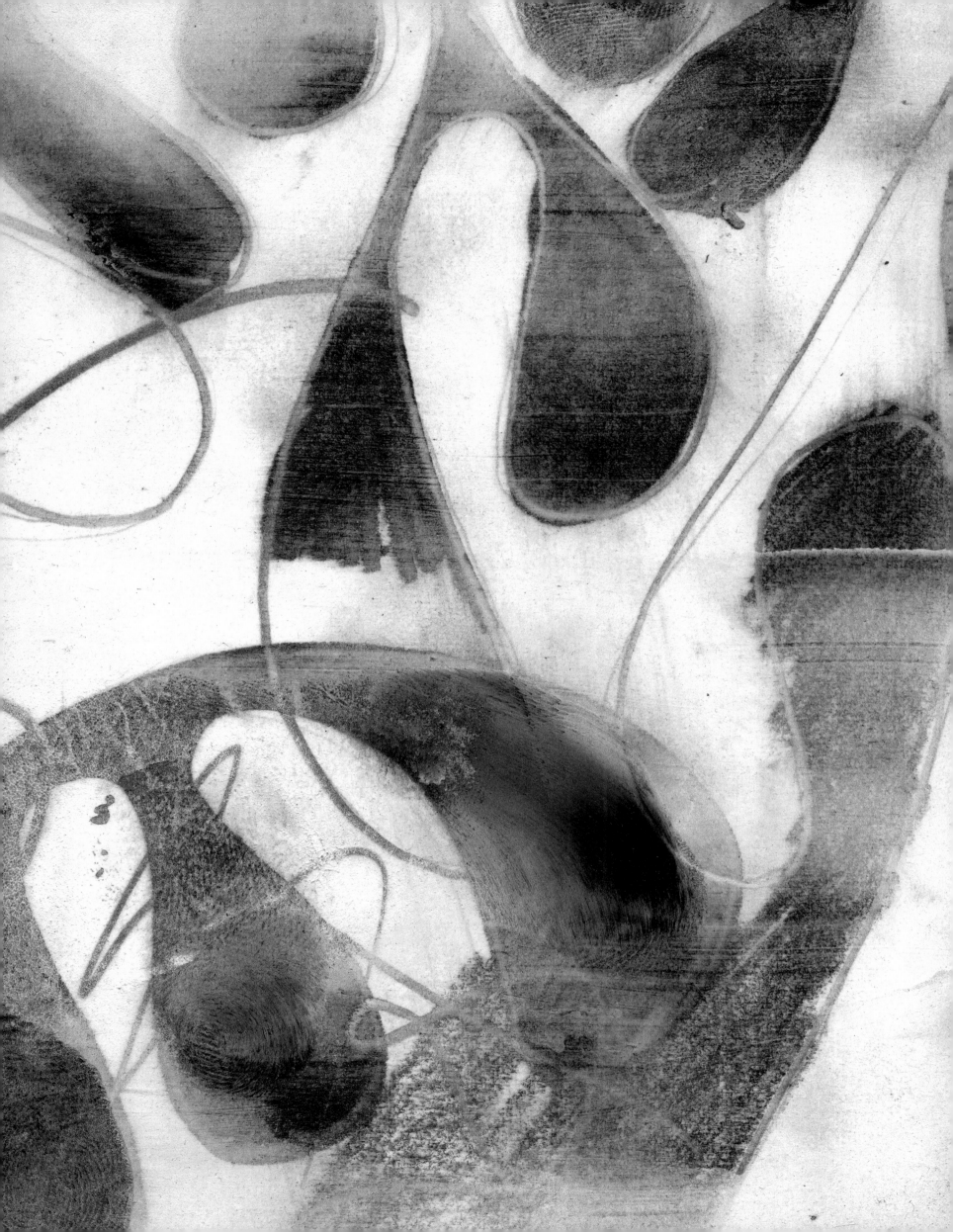

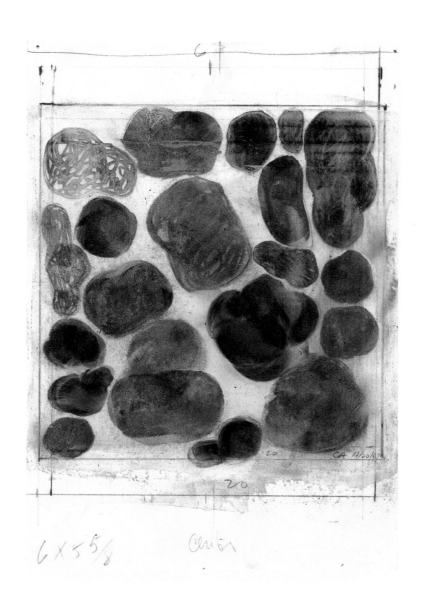

6 X 5⅝

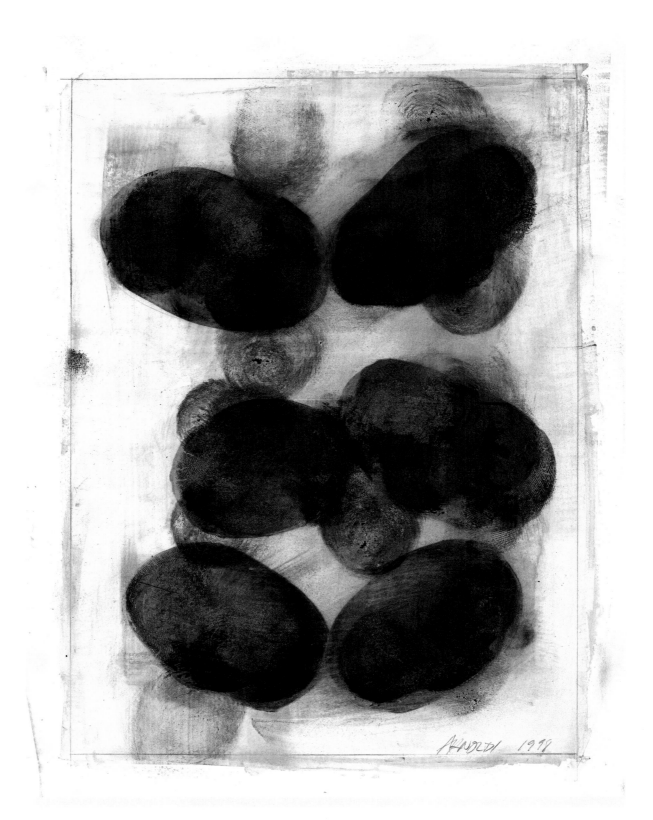

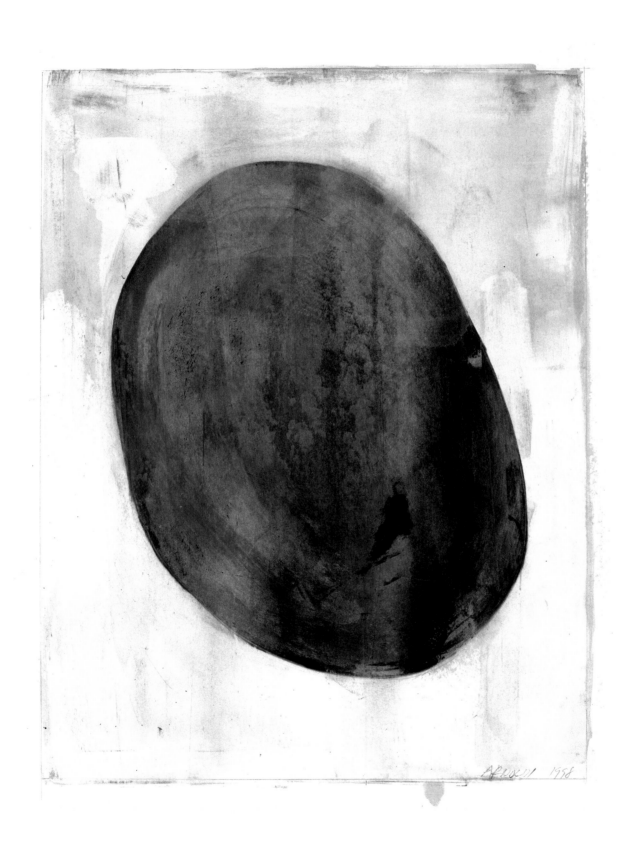

PLATE 48 | **UNTITLED, 1999** GOUACHE ON PAPER, 12¼ x 9 INCHES

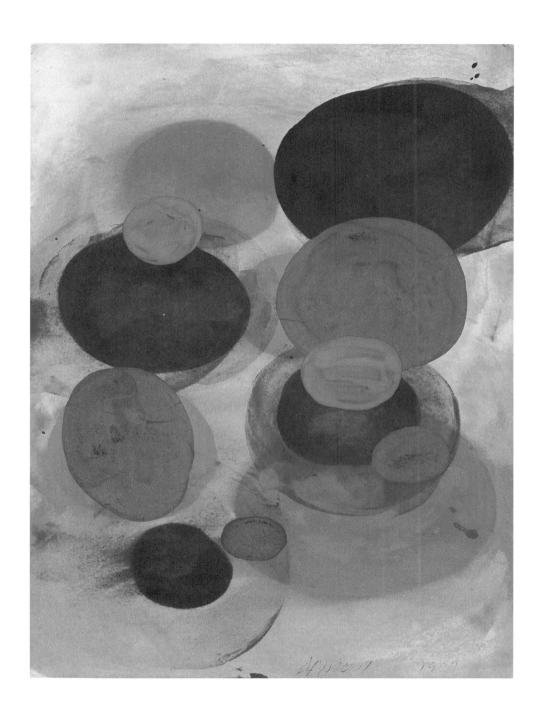

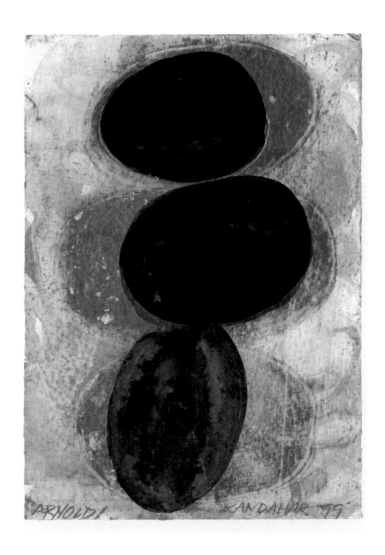

PLATE 49 | UNTITLED, 1999 CHARCOAL & GOUACHE ON PAPER, 6 × 4 INCHES

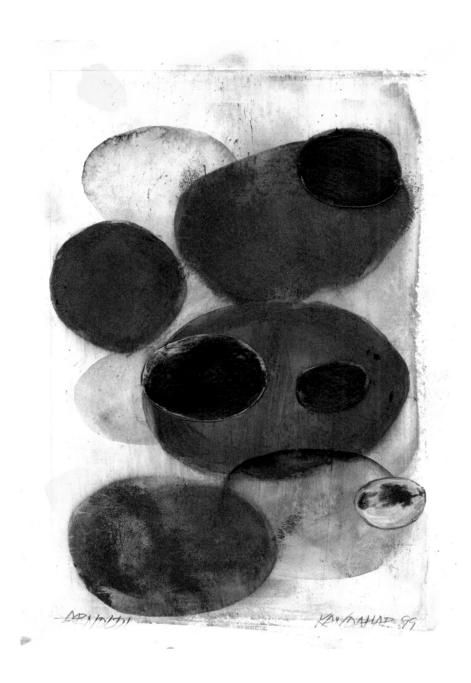

PLATE 50 | UNTITLED, 1999 CHARCOAL & GOUACHE ON PAPER, 10 x 7 INCHES

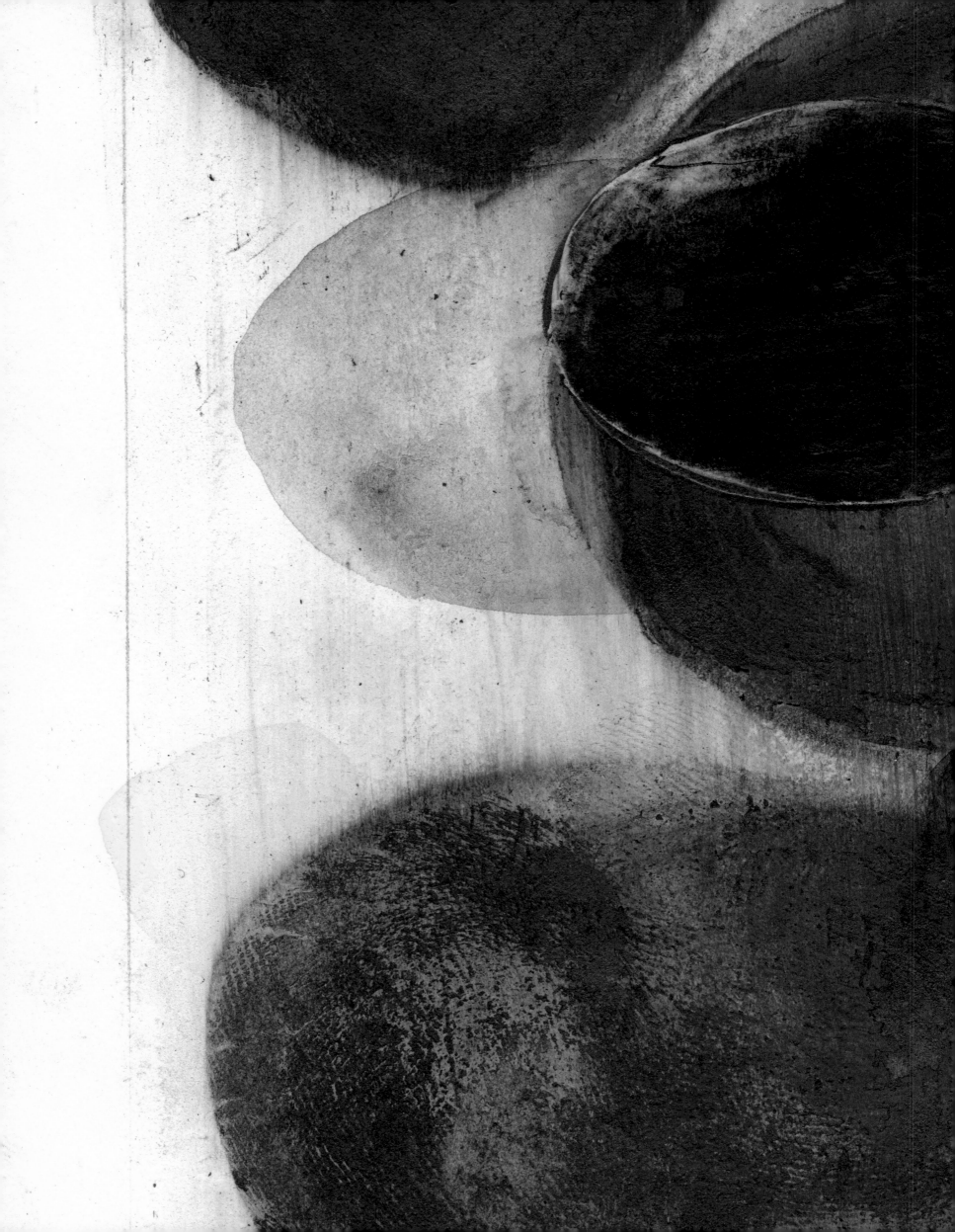

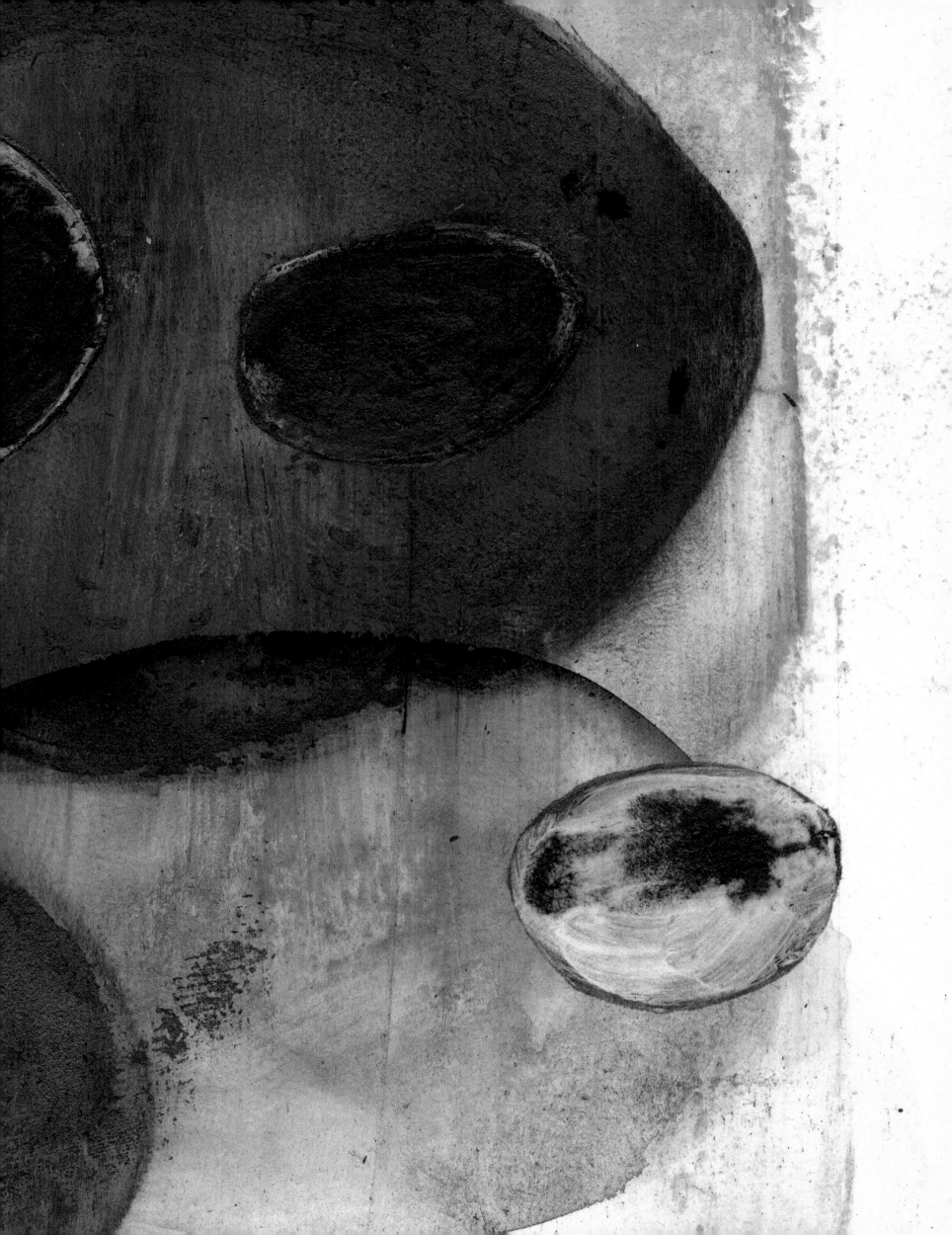

PLATE 51 | UNTITLED, 1998 GRAPHITE & ACRYLIC ON PAPER, 10¼ x 7 INCHES

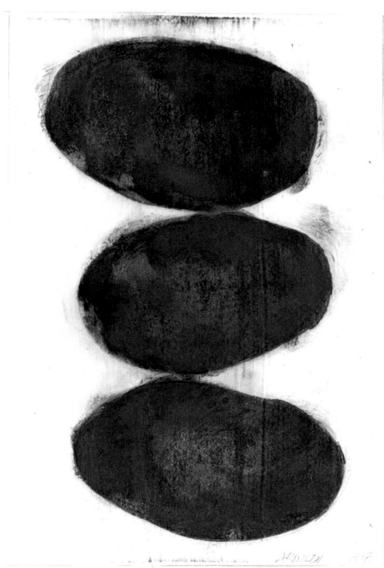

PLATE 52 | **UNTITLED (40), 1998** GRAPHITE, ACRYLIC & GOUACHE ON PAPER, 14 x 12 INCHES

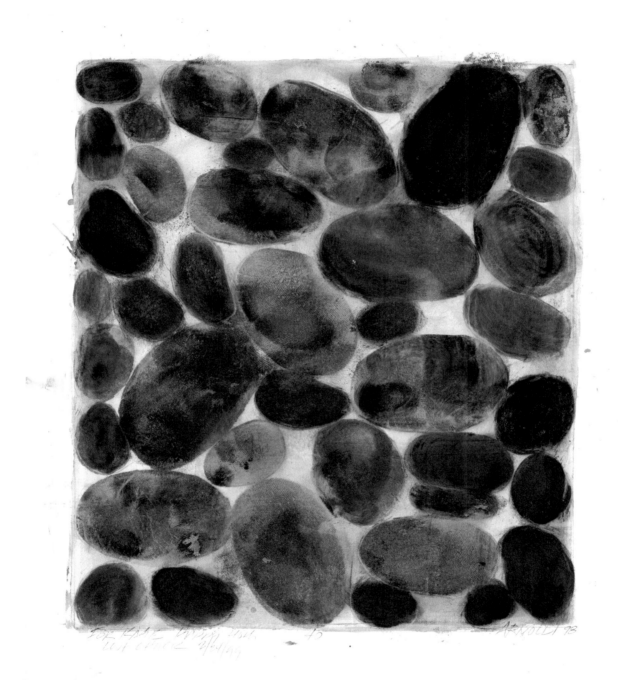

PLATE 53 | **UNTITLED, 2002** GOUACHE ON COLLAGED PAPER, 6⅞ x 6⅞ INCHES

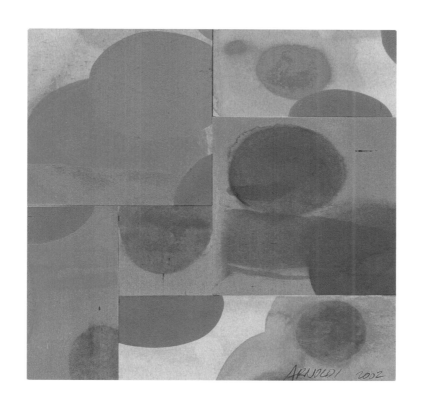

PLATE 54 | UNTITLED, 2002 GOUACHE ON COLLAGED PAPER, 7 x 7 INCHES

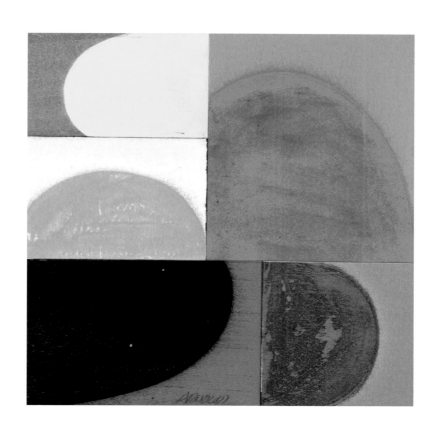

PLATE 55 | **UNTITLED, 2003** GOUACHE ON COLLAGED PAPER, 18 x 17⅞ INCHES

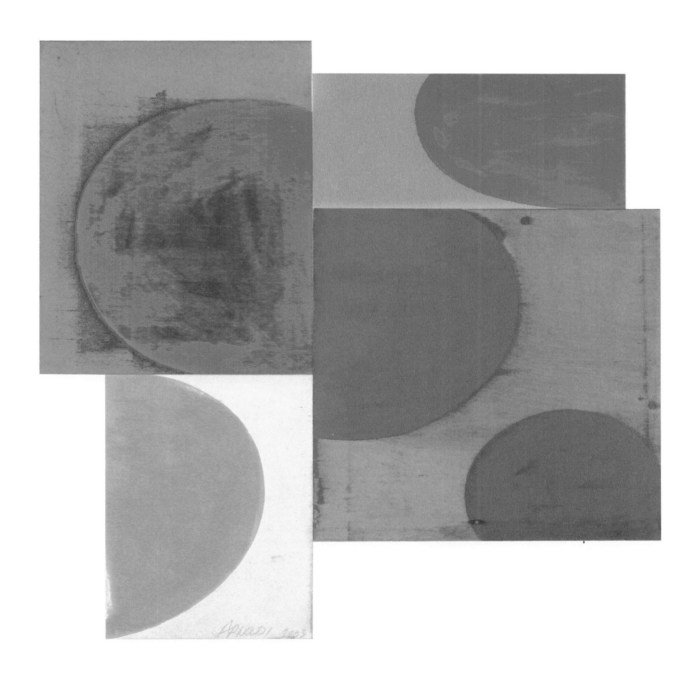

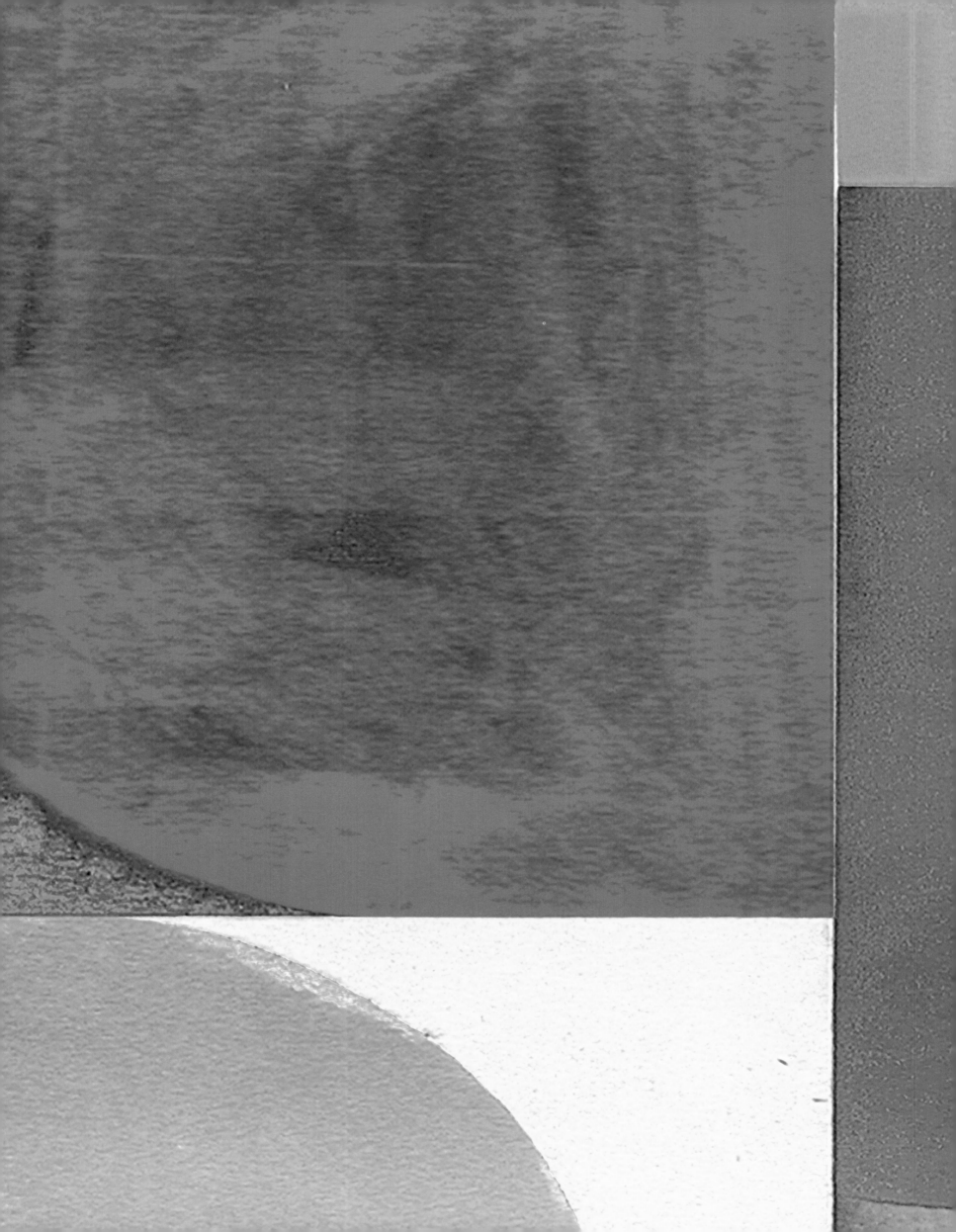

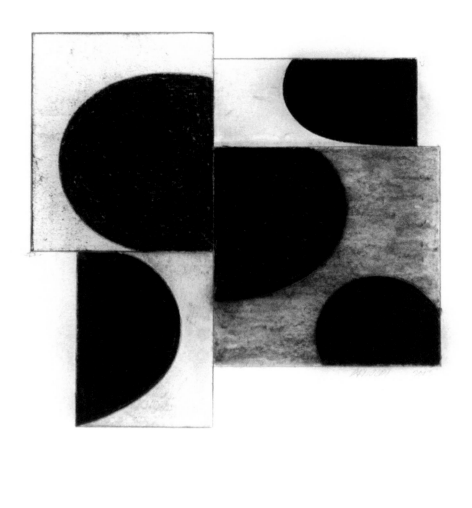

PLATE 56 | UNTITLED, 2003 CHARCOAL ON HANDMADE RAG PAPER, 29½ x 34¼ INCHES

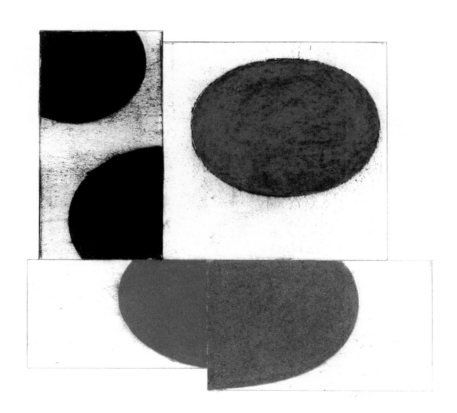

PLATE 57 | UNTITLED, 2003 CHARCOAL & PASTEL ON HANDMADE RAG PAPER, 29½ x 34¼ INCHES

PLATE 58 | **UNTITLED, 2003** GOUACHE ON COLLAGED PAPER, 15¾ x 18¾ INCHES

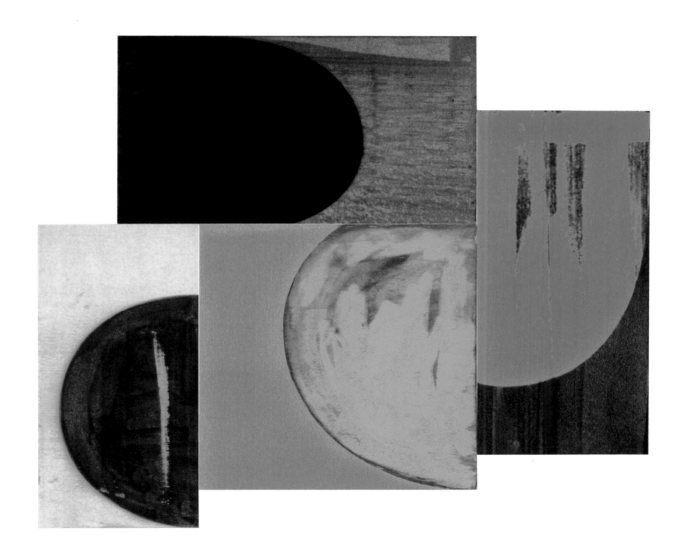

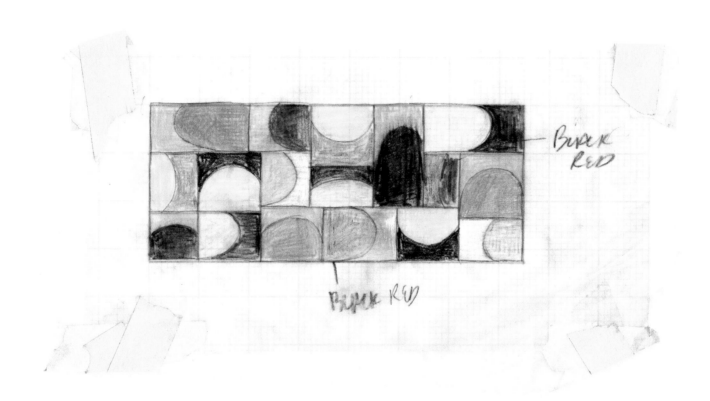

BLACK
RED

BLACK RED

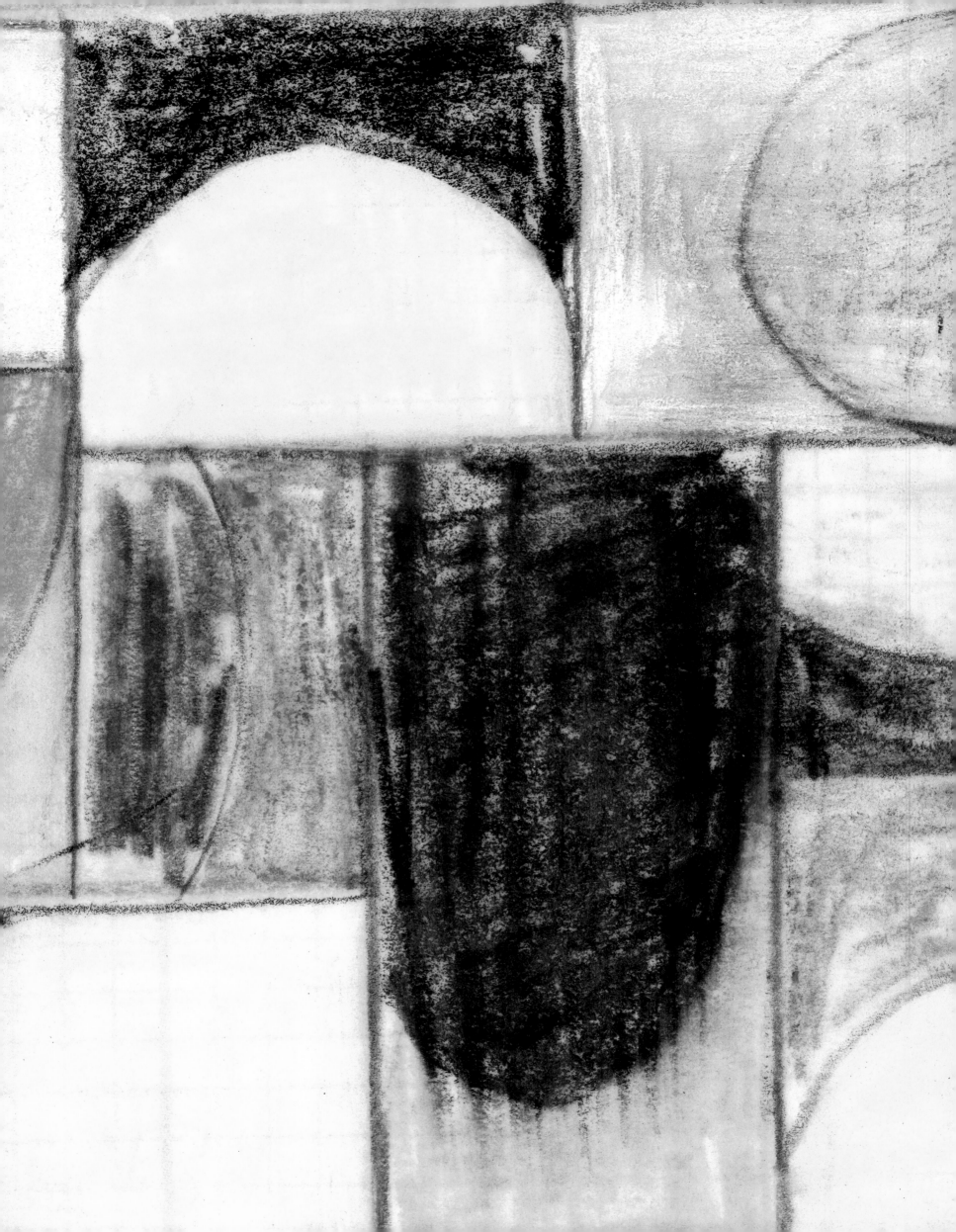

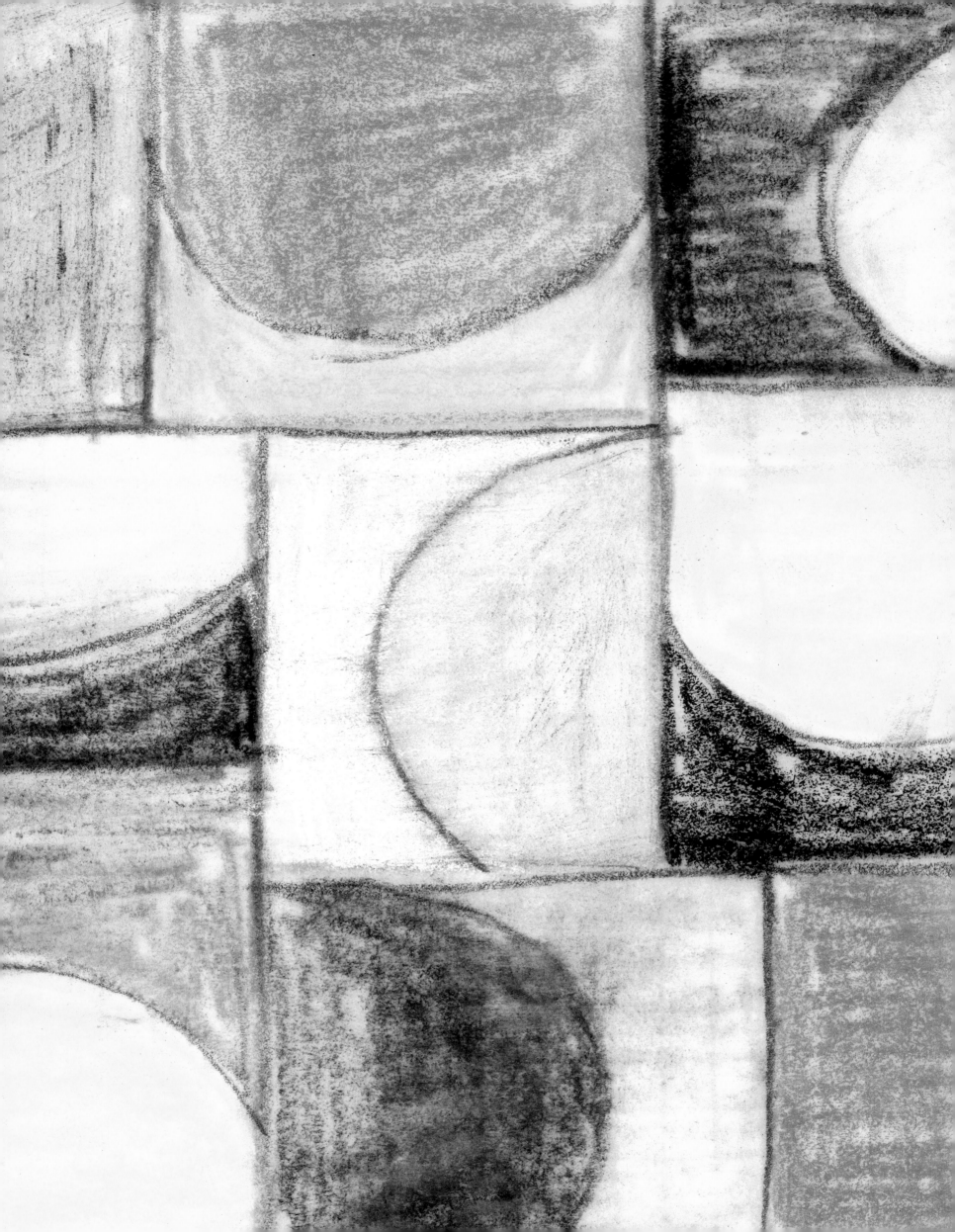

PLATE 60 | **UNTITLED, 2004** GOUACHE ON COLLAGED PAPER, 27½ x 31⅝ INCHES

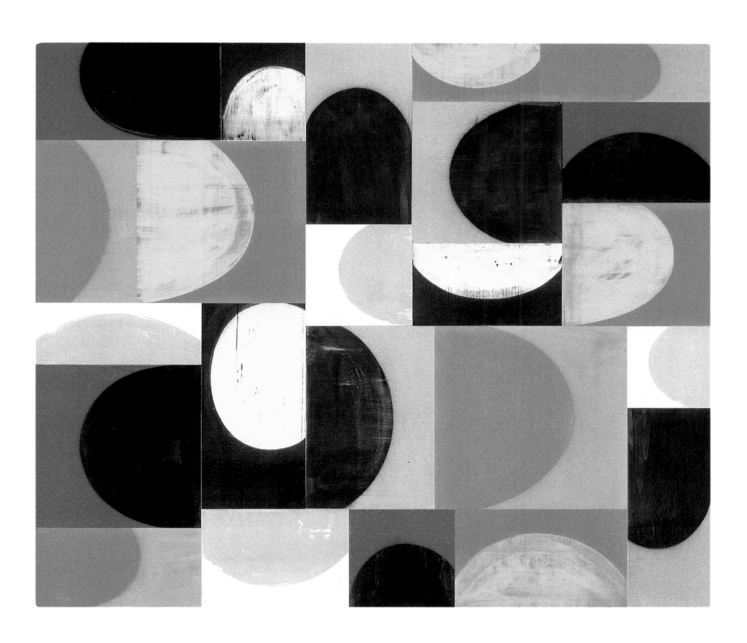

PLATE 61 | **UNTITLED, 2005** GOUACHE ON COLLAGED PAPER, 15 x 15¾ INCHES

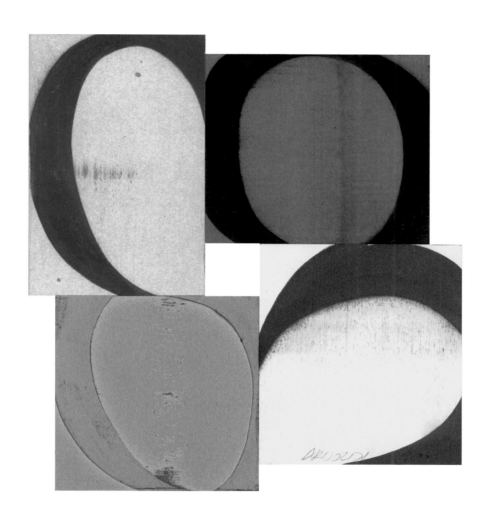

PLATE 62 | **UNTITLED, 2005** GOUACHE ON COLLAGED PAPER, 35¾ x 35¾ INCHES

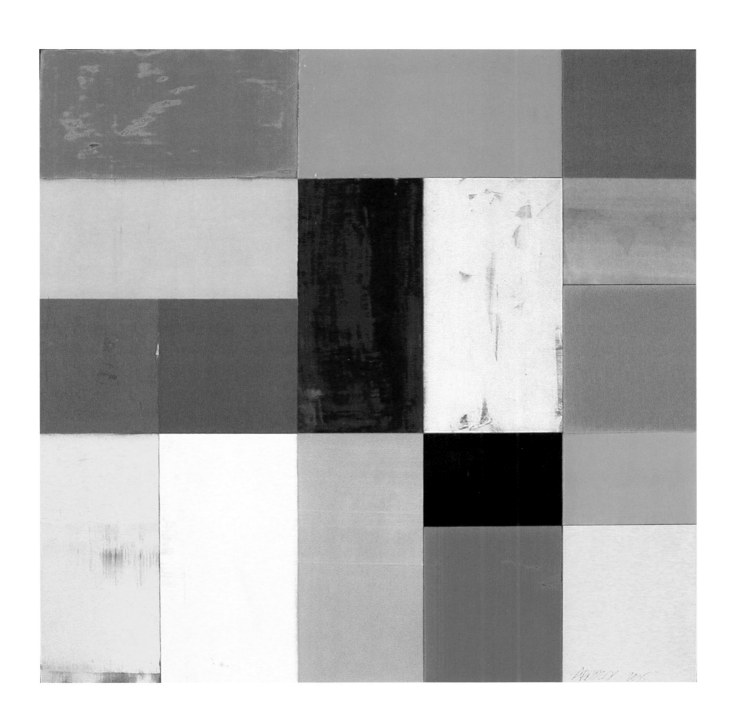

PLATE 63 | **UNTITLED, 2005** INK & GOUACHE ON PAPER, 8 x 6 INCHES

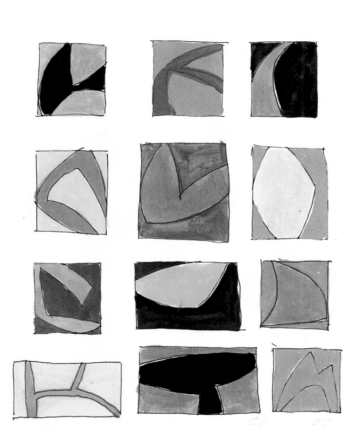

PLATE 64 | **UNTITLED, 2006** GOUACHE ON PAPER, 8¾ x 7 INCHES

FOLLOWING PAGES:

PLATE 65 | **UNTITLED, 2007** GOUACHE ON PAPER, 21 x 18⅛ INCHES

PLATE 66 | **UNTITLED, 2007** GOUACHE ON PAPER, 21¼ x 18 INCHES

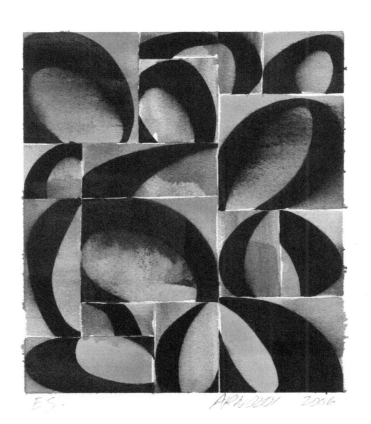

E.S. ARNOLDI 2006

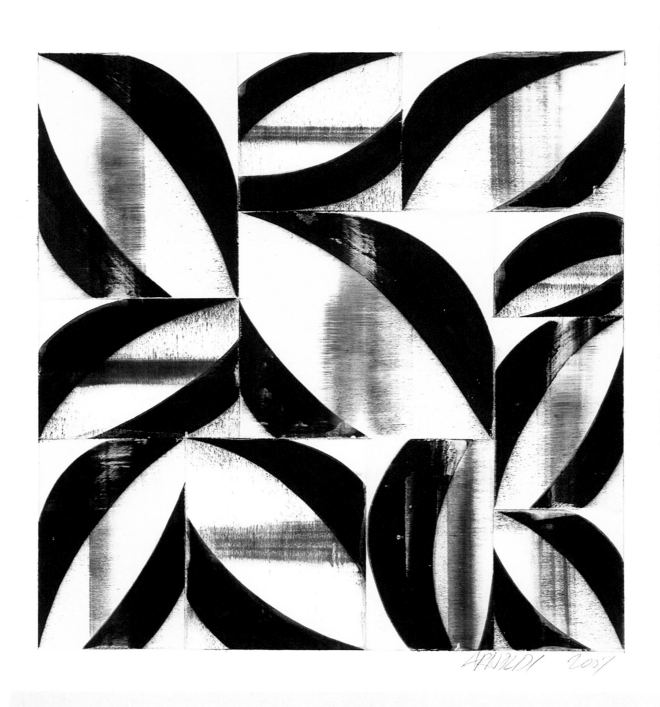

ARNDT 2001

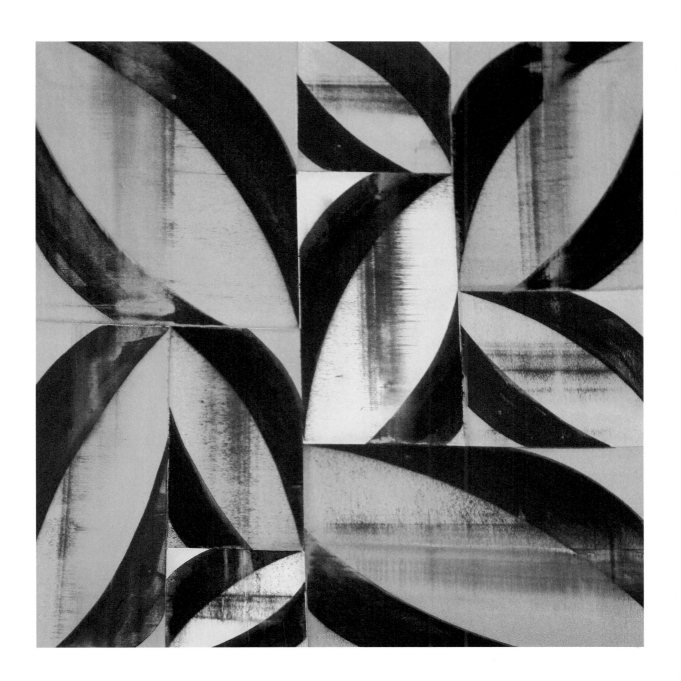

PLATE 67 | UNTITLED, 2007 GOUACHE ON PAPER, 11¾ x 11 INCHES

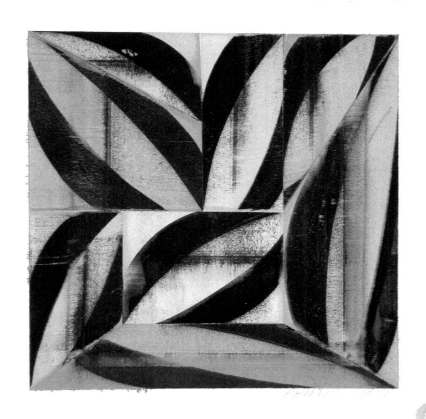

PLATE 68 | UNTITLED, 2007 GOUACHE ON COLLAGED PAPER, 26¼ x 22⅝ INCHES

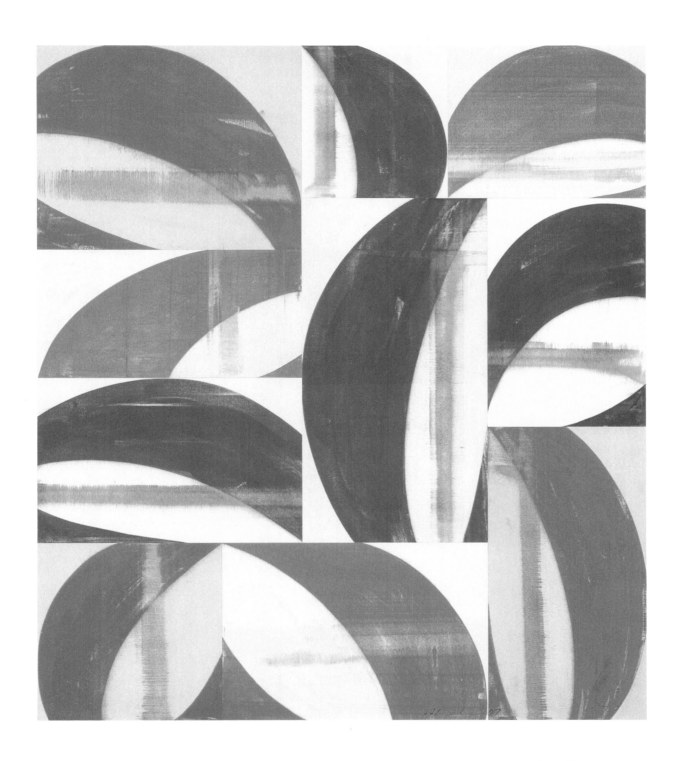

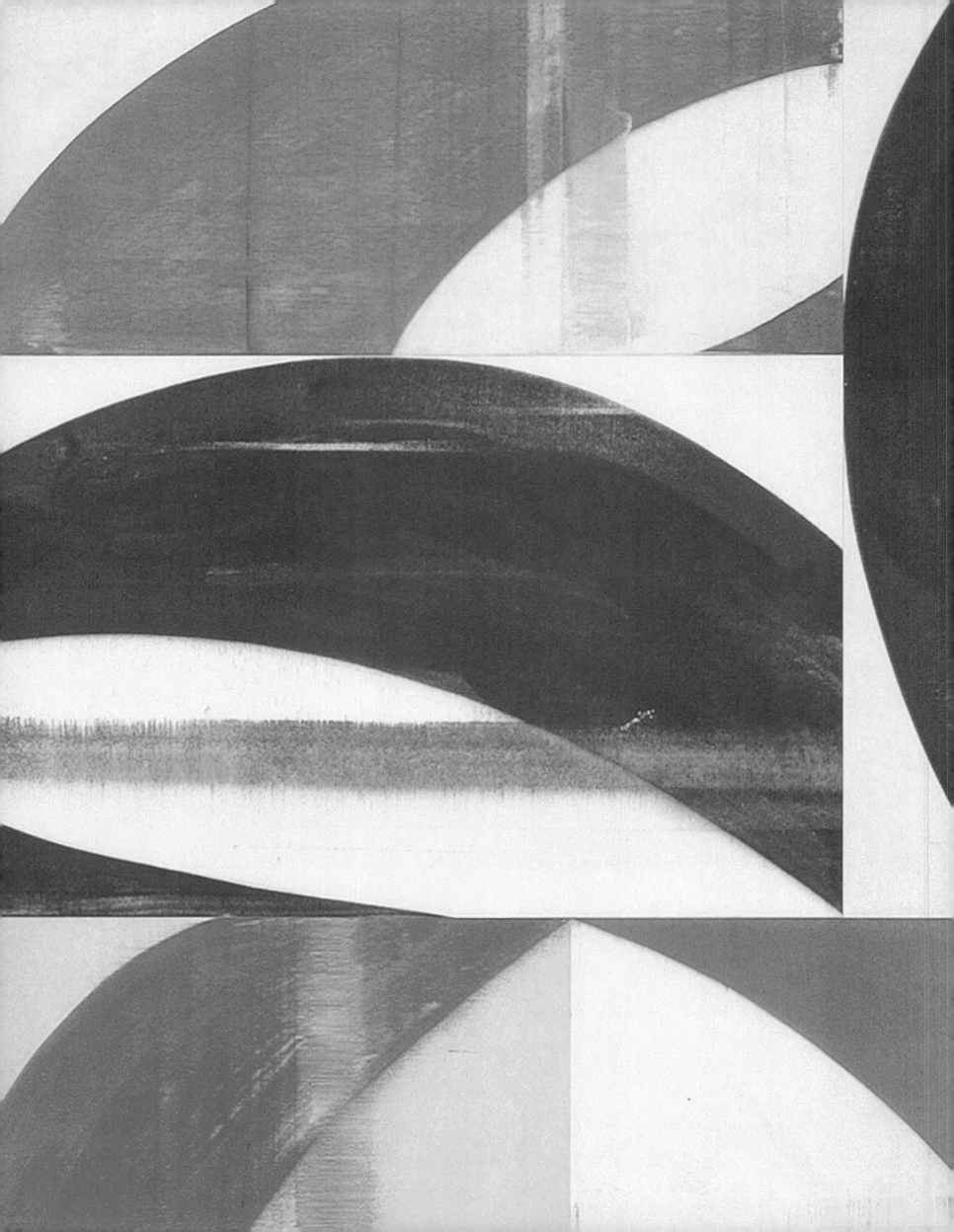

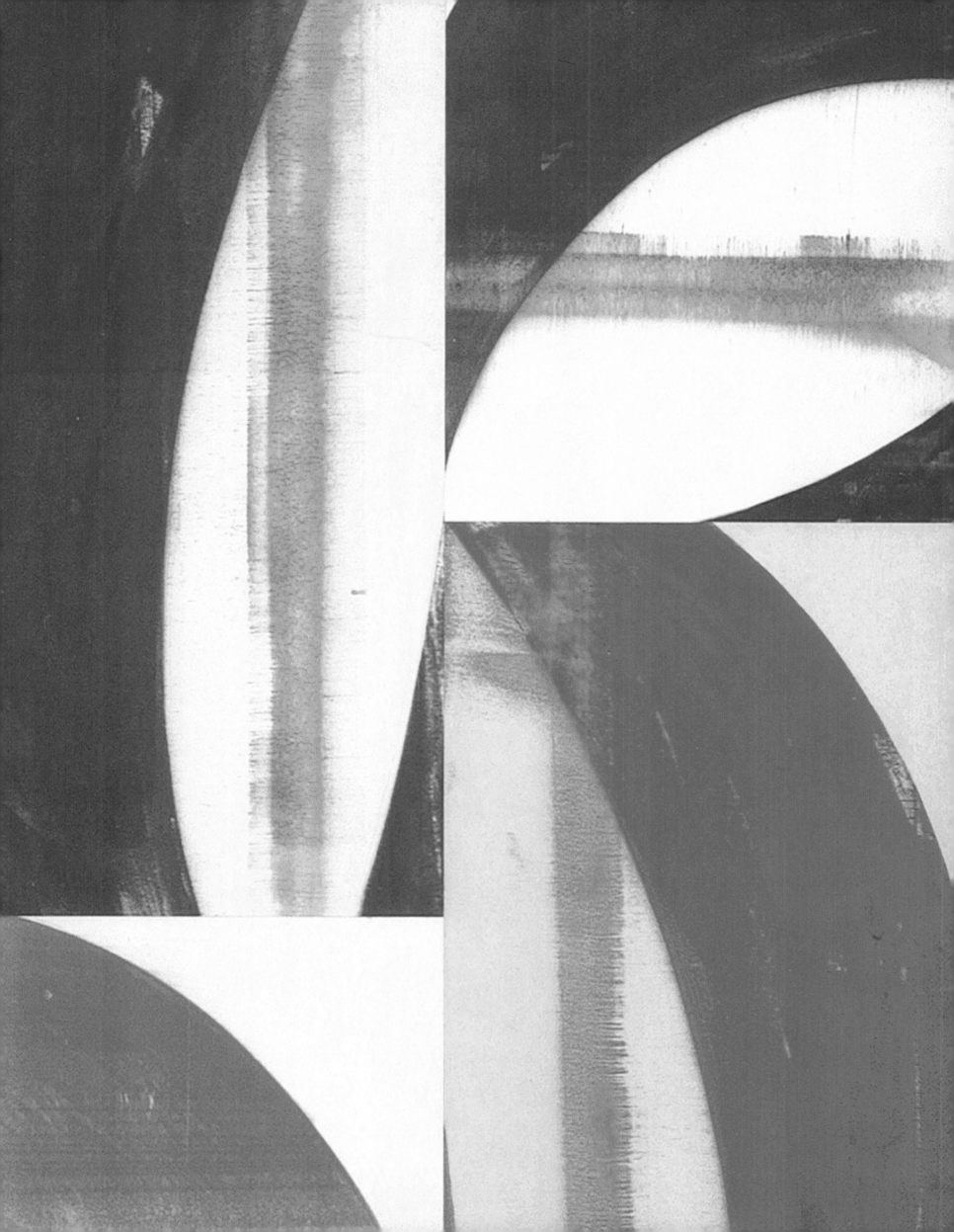

PLATE 69 | **UNTITLED, 2010** GOUACHE ON PAPER, 12¼ x 9 INCHES

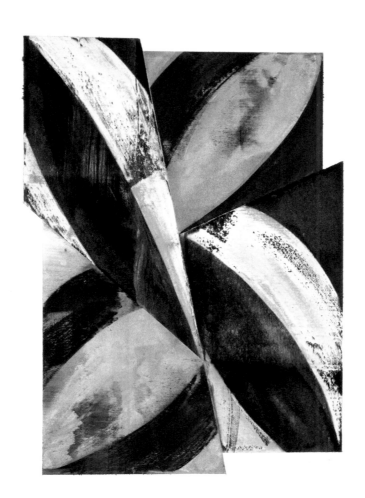

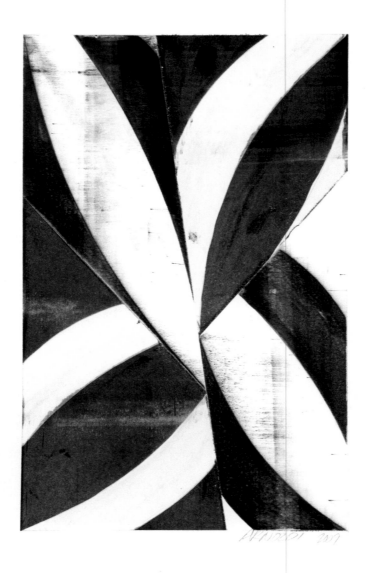

PLATE 70 | UNTITLED, 2009 GOUACHE ON PAPER, 17¾ x 12 INCHES

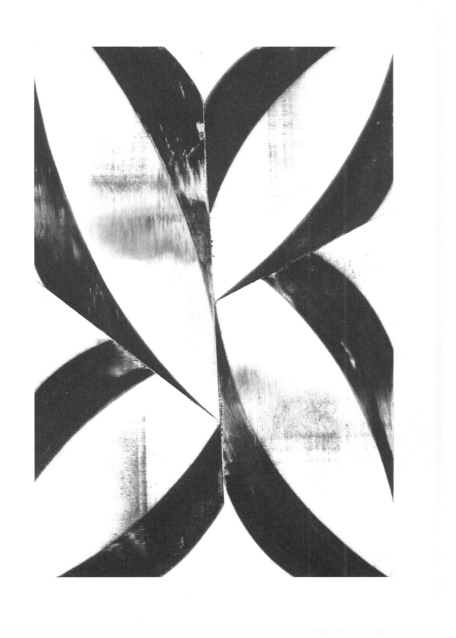

PLATE 71 | UNTITLED, 2008 GOUACHE ON PAPER, 15½ x 11½ INCHES

PLATE 72 | UNTITLED, 2010 GOUACHE ON PAPER, 16 x 12 INCHES

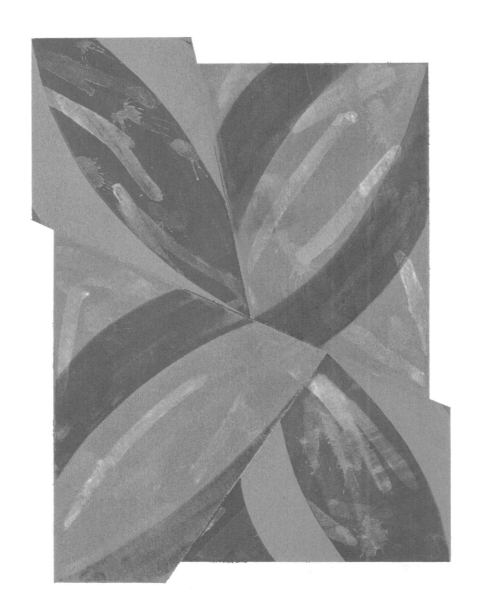

PLATE 73 | UNTITLED, 2006 GOUACHE ON COLLAGED PAPER, 7¼ x 13¼ INCHES

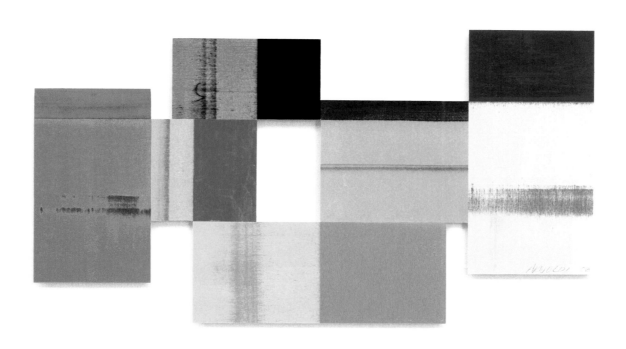

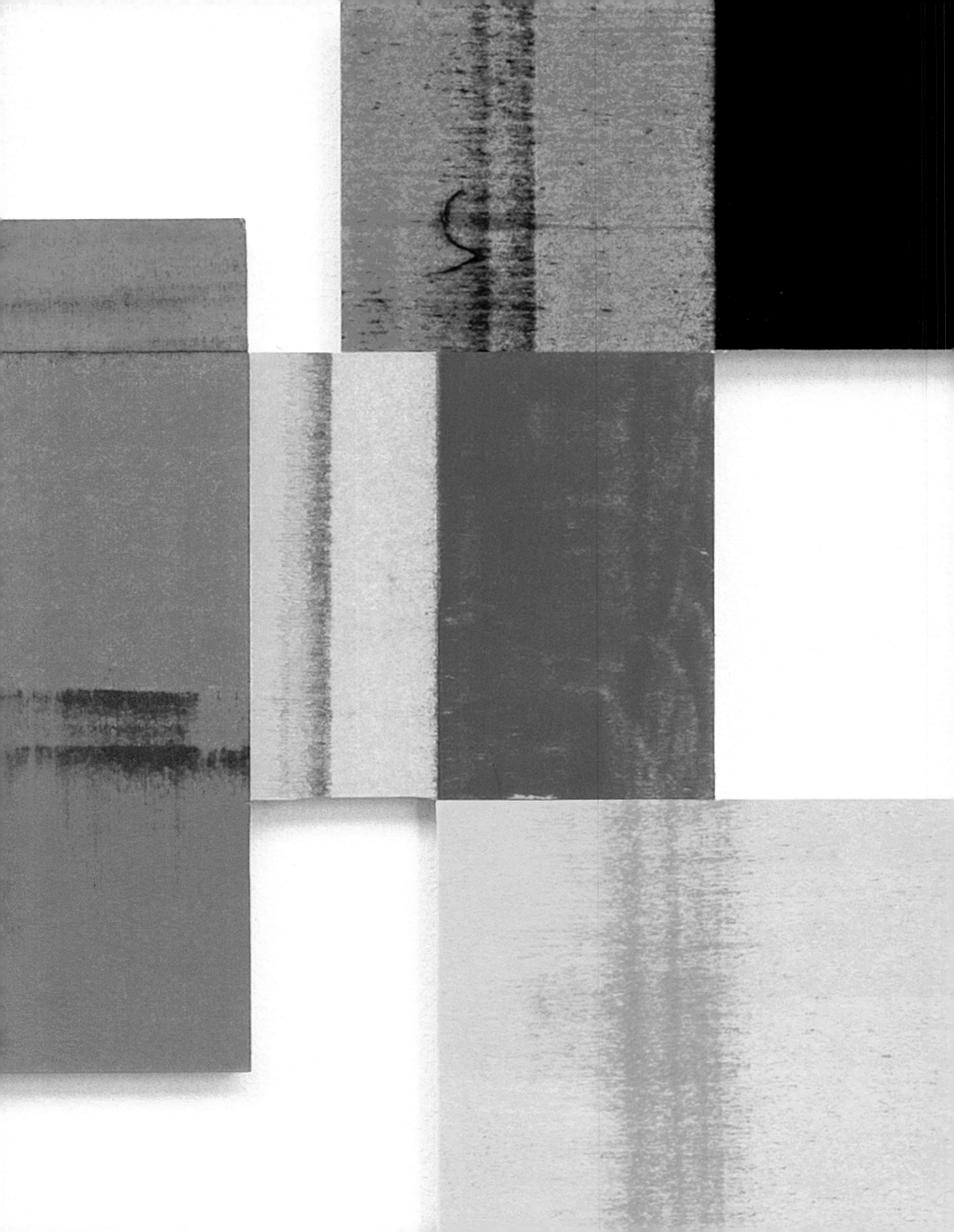

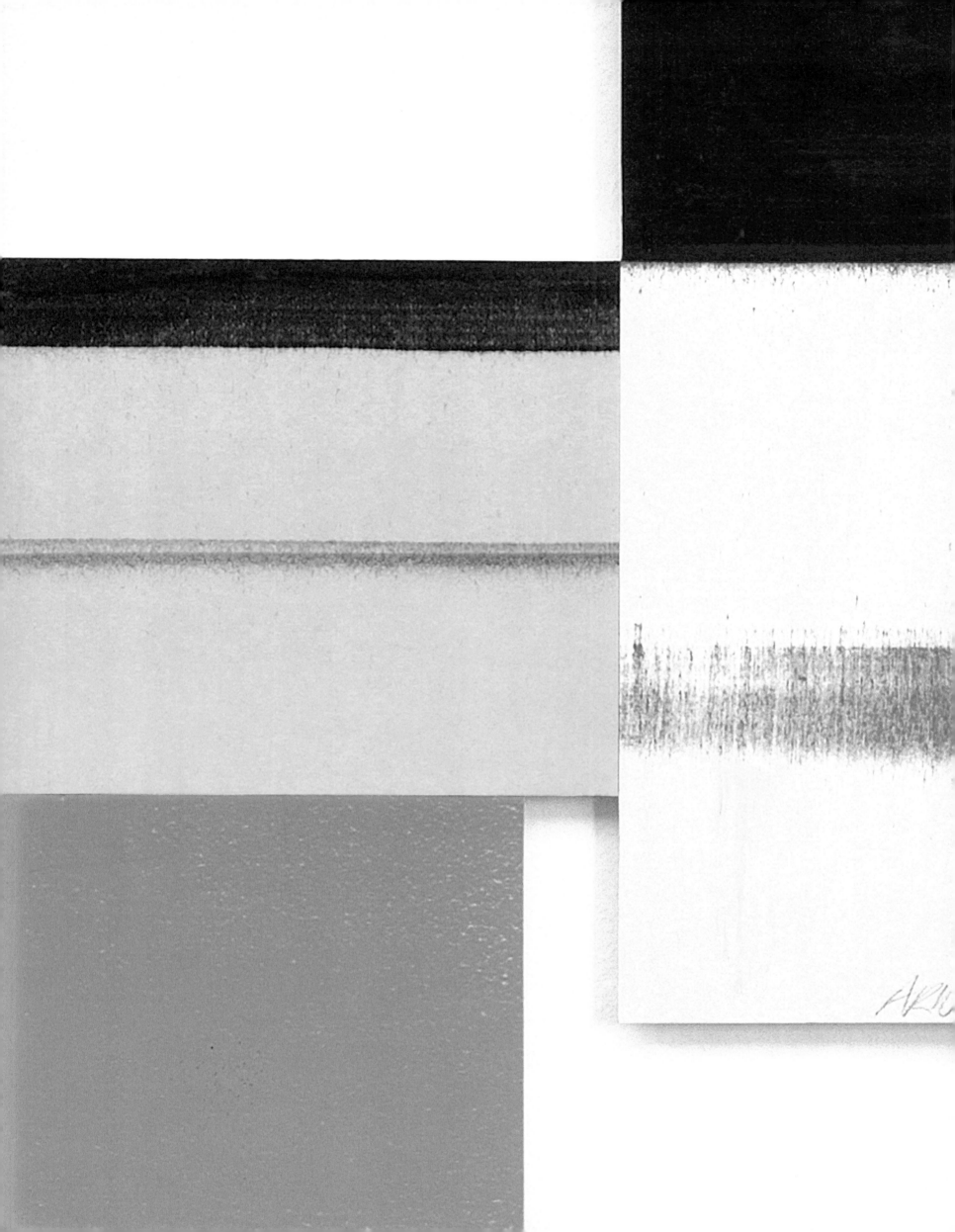

PLATE 74 | UNTITLED, 2007 GOUACHE ON PAPER, 21 x 18 INCHES

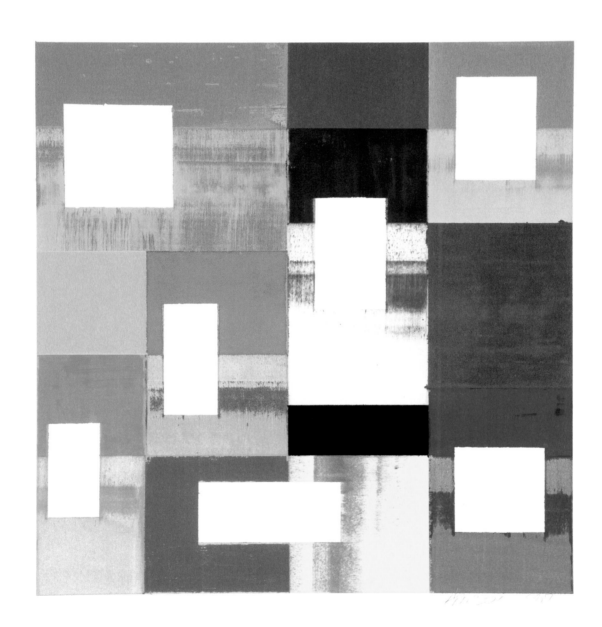

PLATE 75 | UNTITLED, 2007 GOUACHE ON PAPER, 21 x 18 INCHES

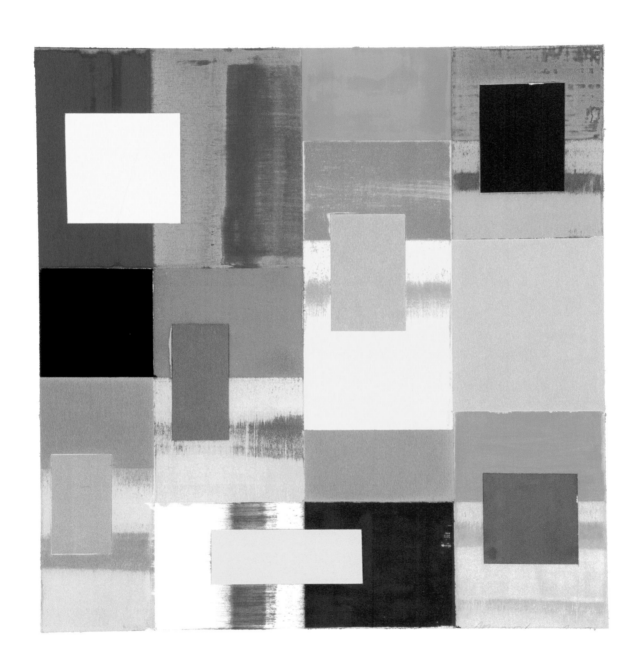

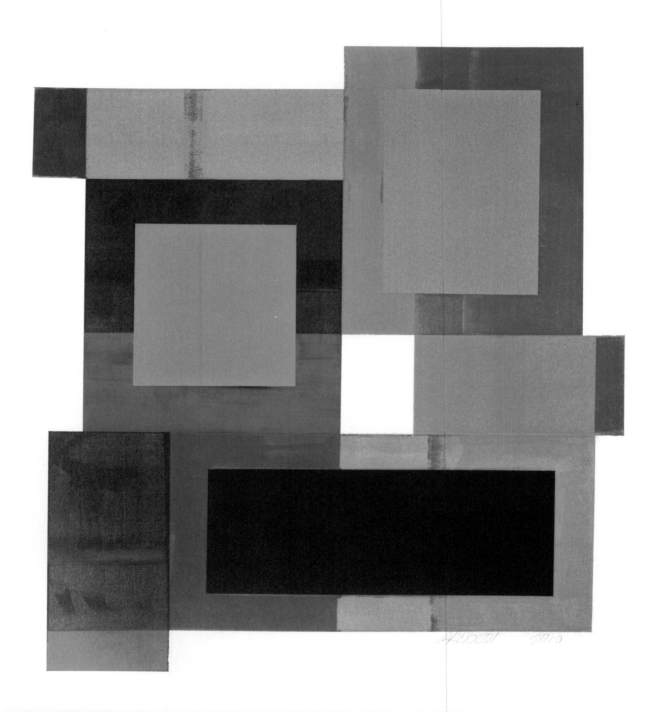

PLATE 76 | UNTITLED, 2010 GOUACHE ON PAPER, 24 x 18 INCHES

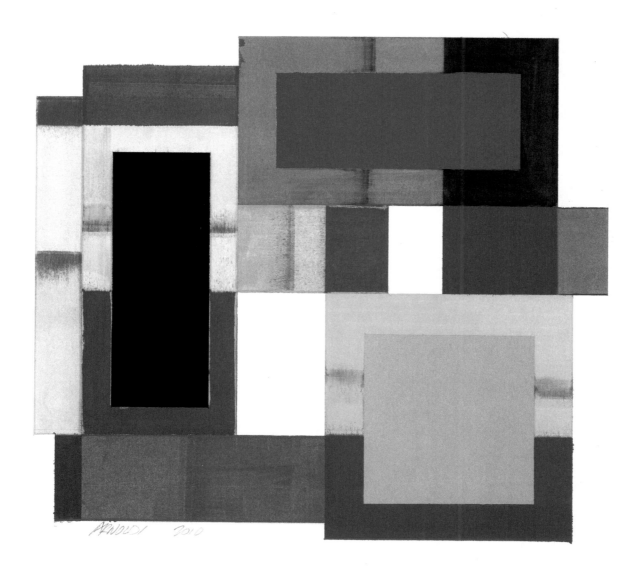

PLATE 77 | UNTITLED, 2010 GOUACHE ON PAPER, 18 x 18 INCHES

PLATE 78 | UNTITLED (SAVU SAVU FIJI), 2010 GOUACHE ON PAPER, 15½ x 12¼ INCHES

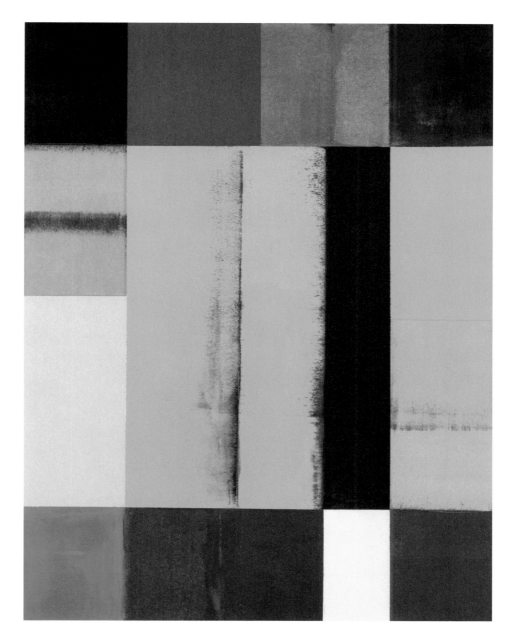

PLATE 79 | **UNTITLED, 1992** GOUACHE ON PAPER, 12 x 9 INCHES

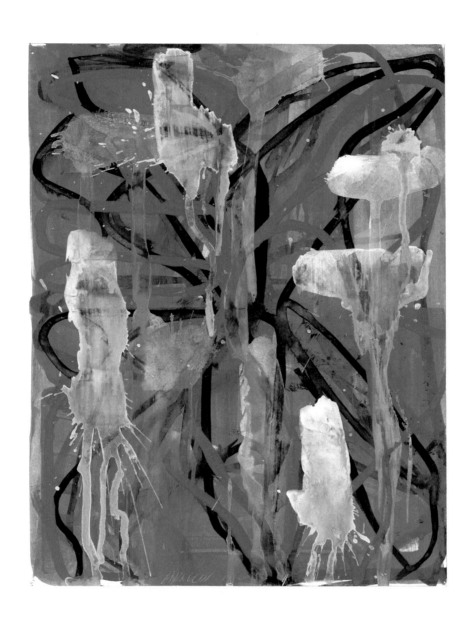

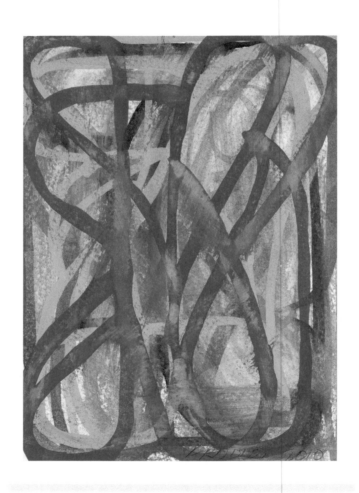

PLATE 80 | UNTITLED, 2010 GOUACHE ON PAPER, 6 x 4 INCHES

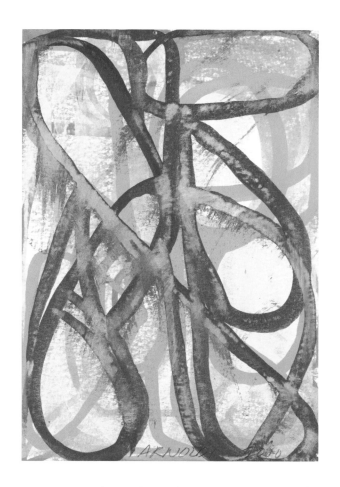

PLATE 81 | UNTITLED, 2010 GOUACHE ON PAPER, 6 x 4 INCHES

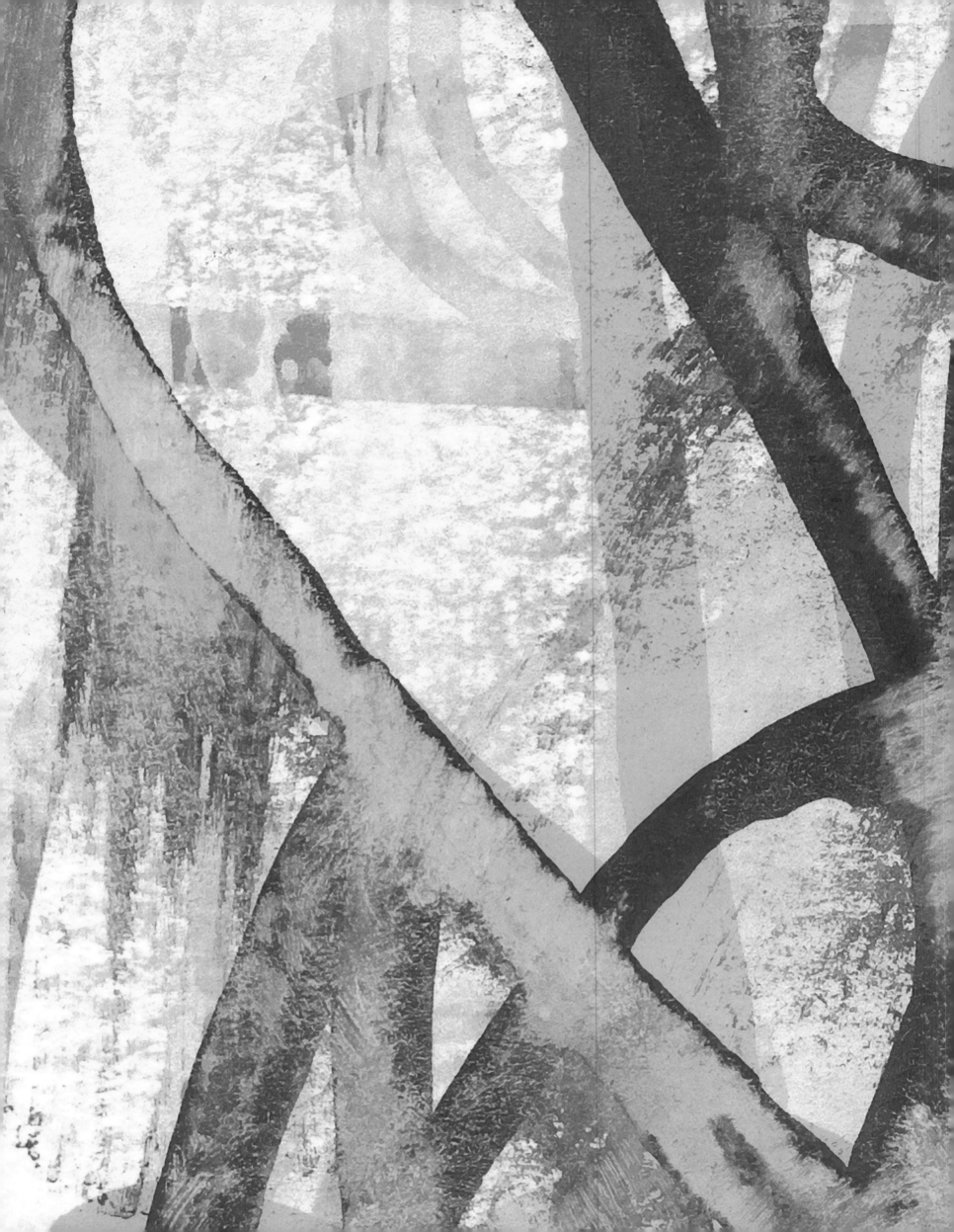

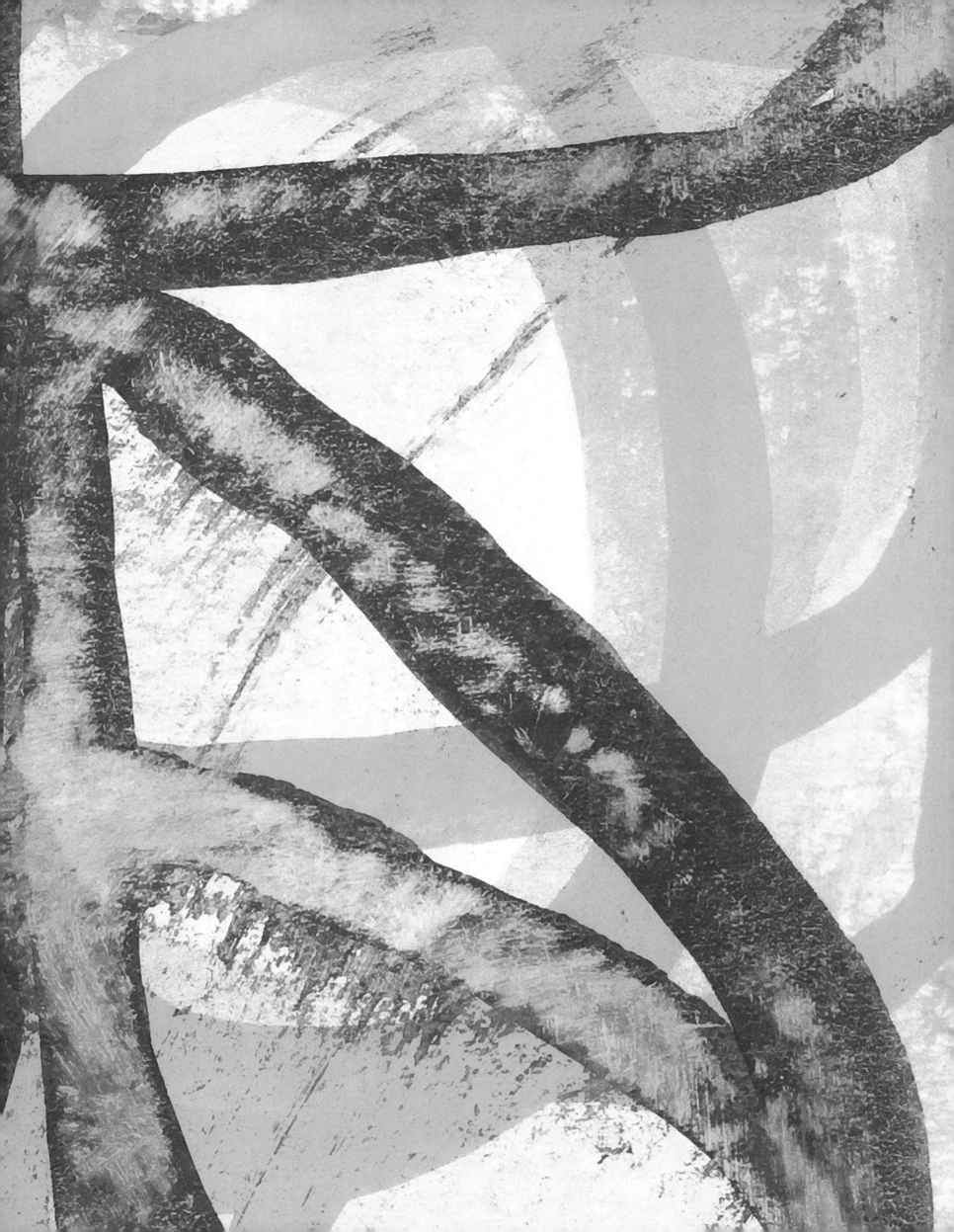

PLATE 82 | UNTITLED, 2010 GOUACHE ON PAPER, 6 x 4 INCHES

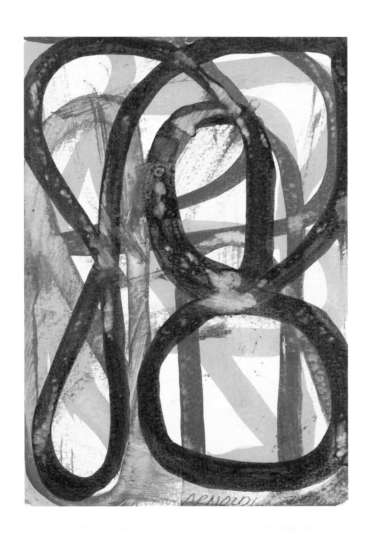

PLATE 83 | **UNTITLED, 2011** GOUACHE ON PAPER, 12¼ x 9 INCHES

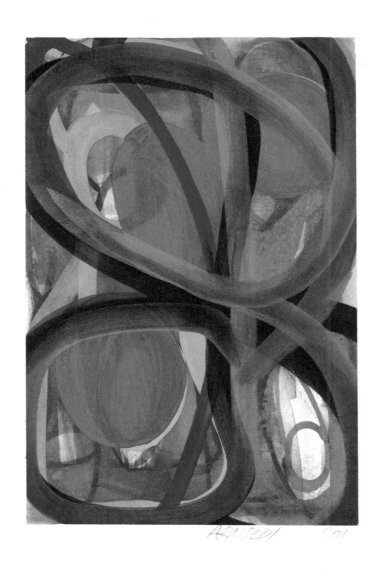

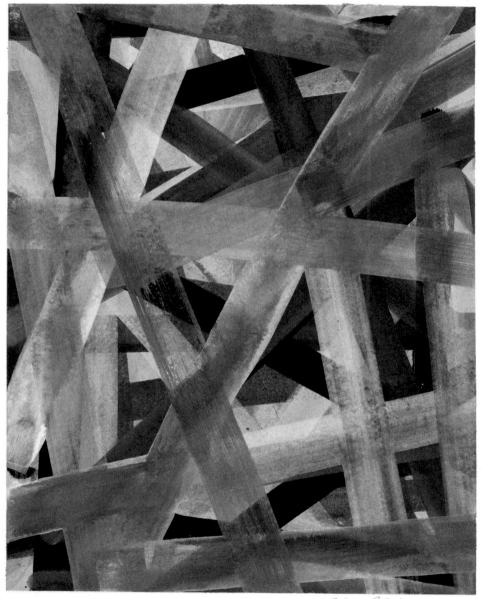

CA. 2011

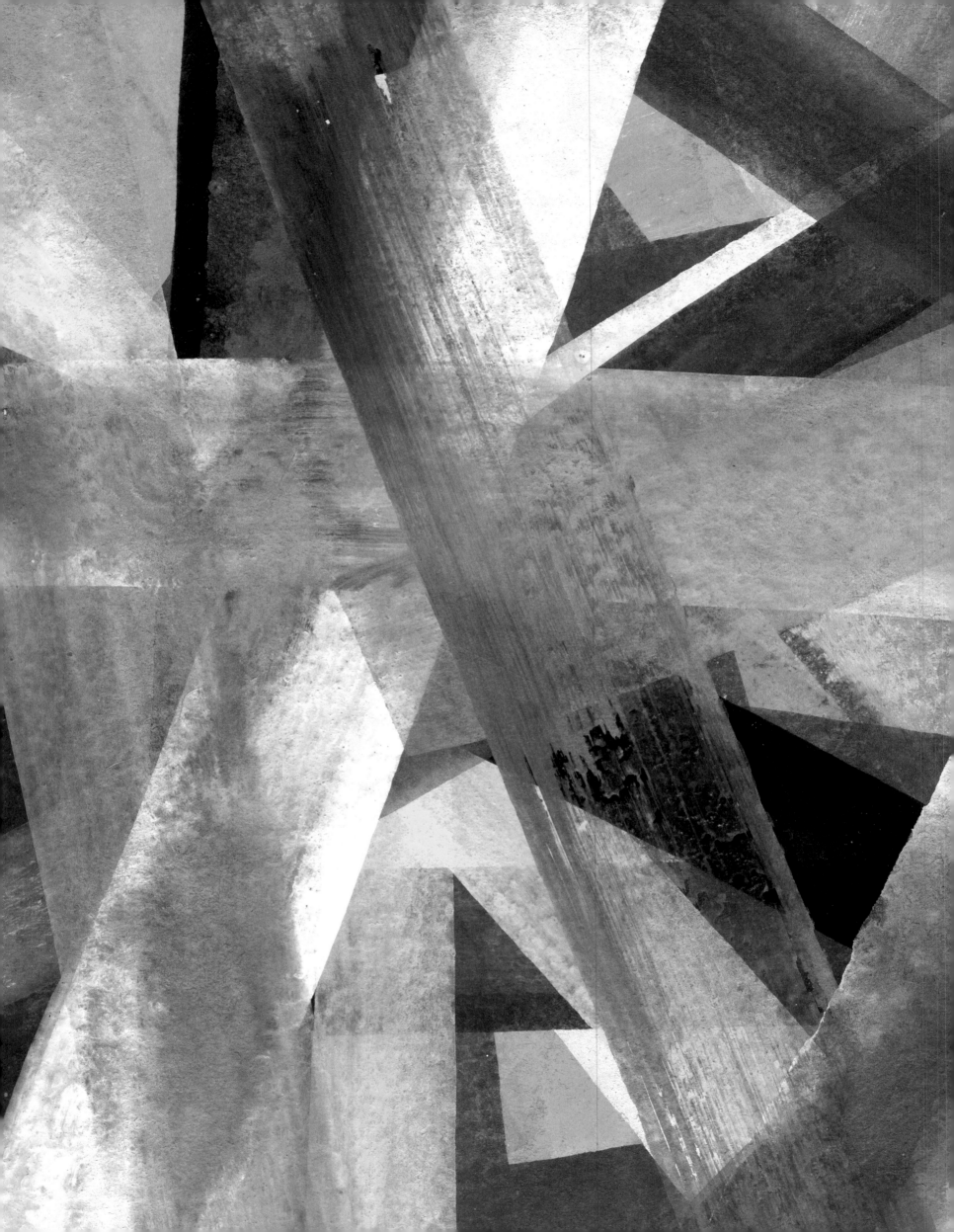

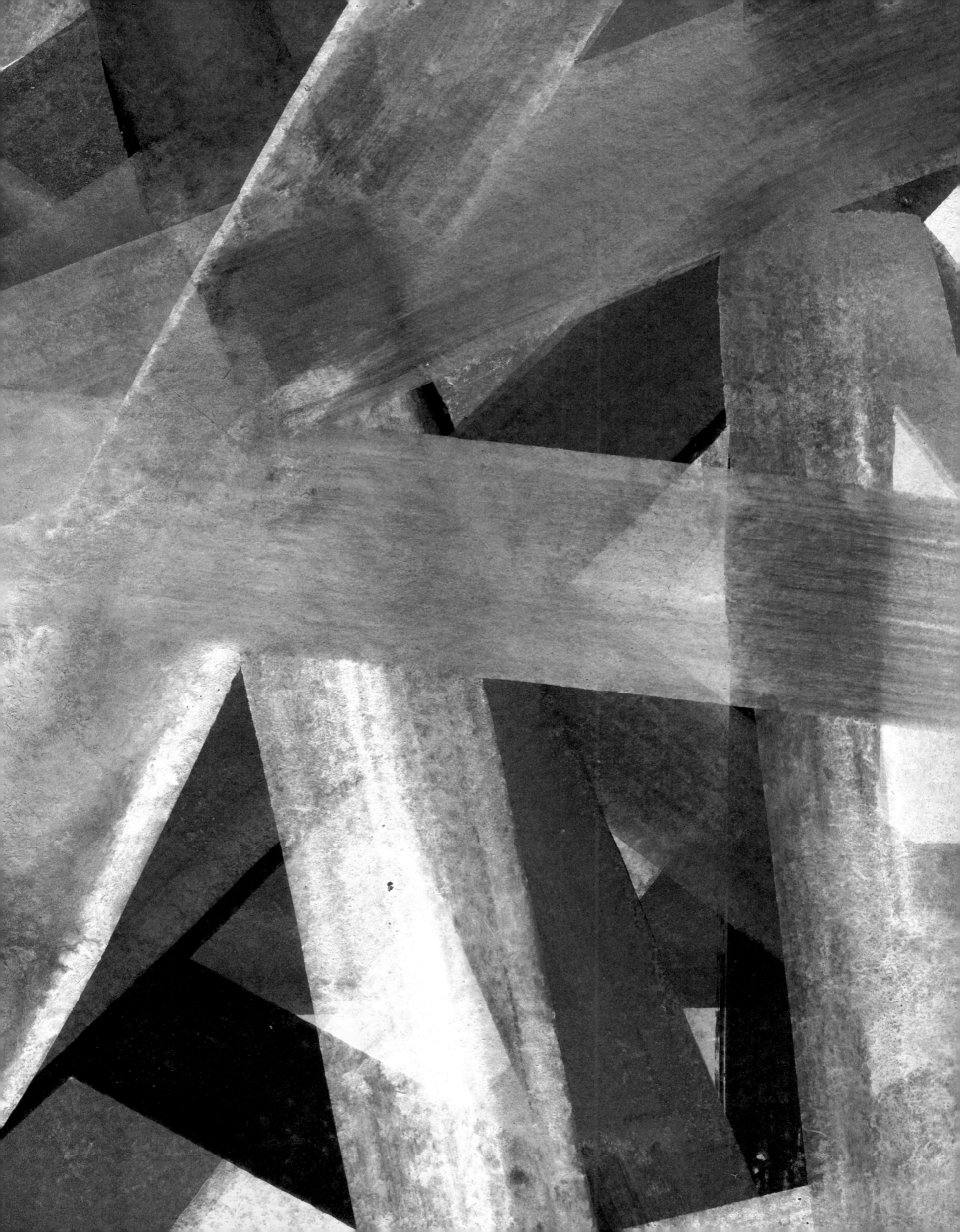

PLATE 85 | **UNTITLED, 2011** GOUACHE ON PAPER, 24 x 18 INCHES

FOLLOWING PAGES:

PLATE 86 | **UNTITLED, 2011** GOUACHE ON PAPER, 23¼ x 18¼ INCHES

PLATE 87 | **UNTITLED, 2011** GOUACHE ON PAPER, 24 x 18 INCHES

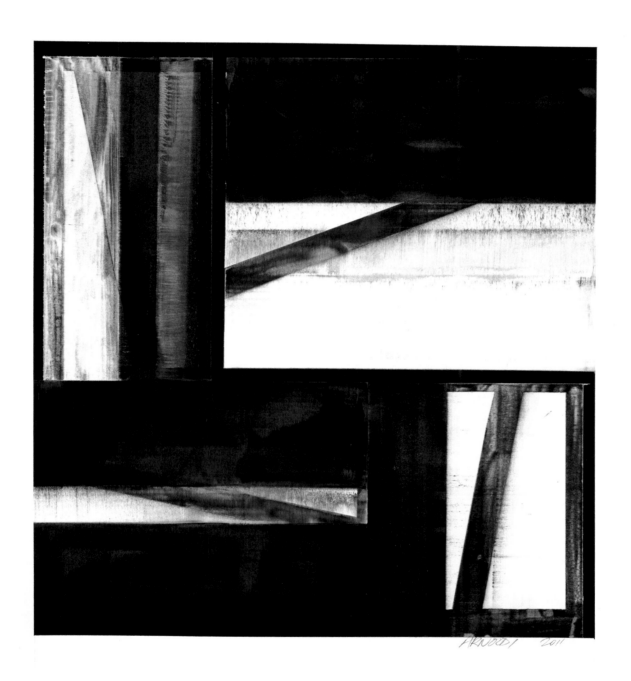

ARNOLD 2011

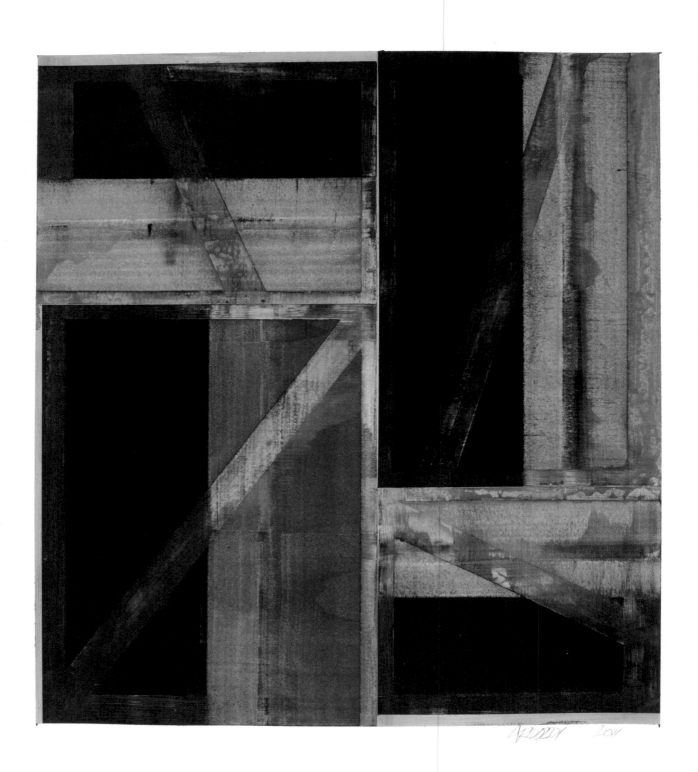

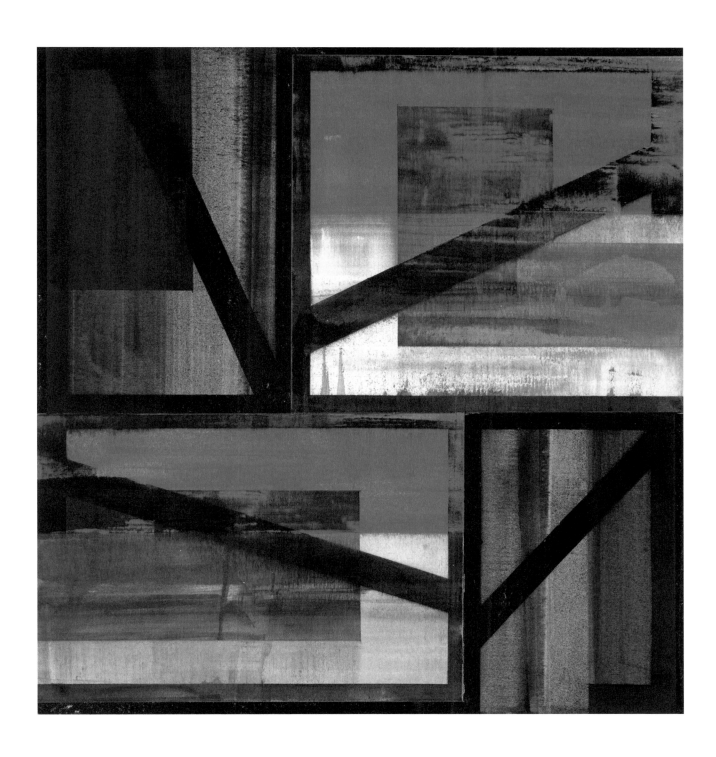

PLATE 88 | **UNTITLED, 2012** GOUACHE ON PAPER, 12 x 10 INCHES

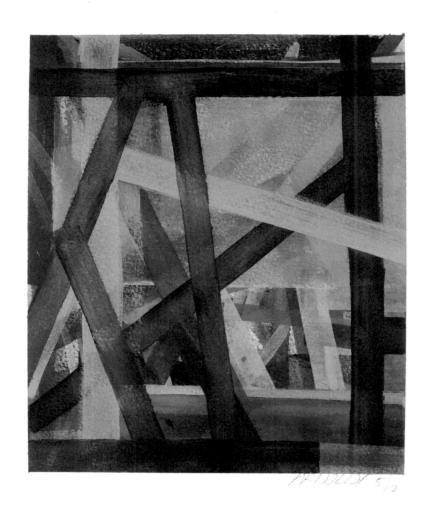

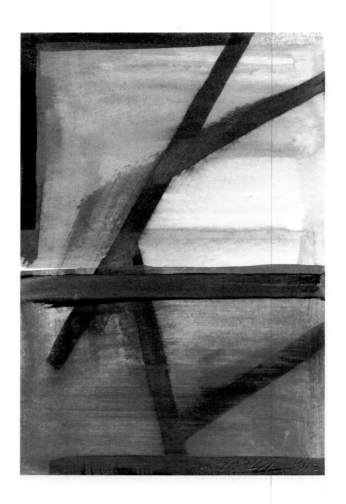

PLATE 89 | UNTITLED, 2012 GOUACHE ON PAPER, 6 x 4 INCHES

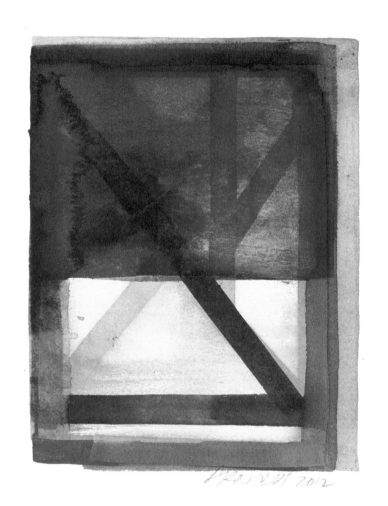

PLATE 90 | UNTITLED, 2012 GOUACHE ON PAPER, 9 x 5½ INCHES

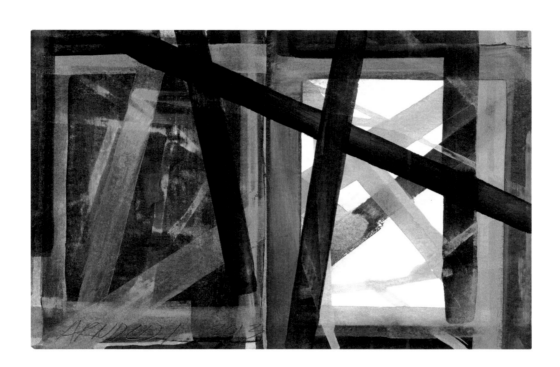

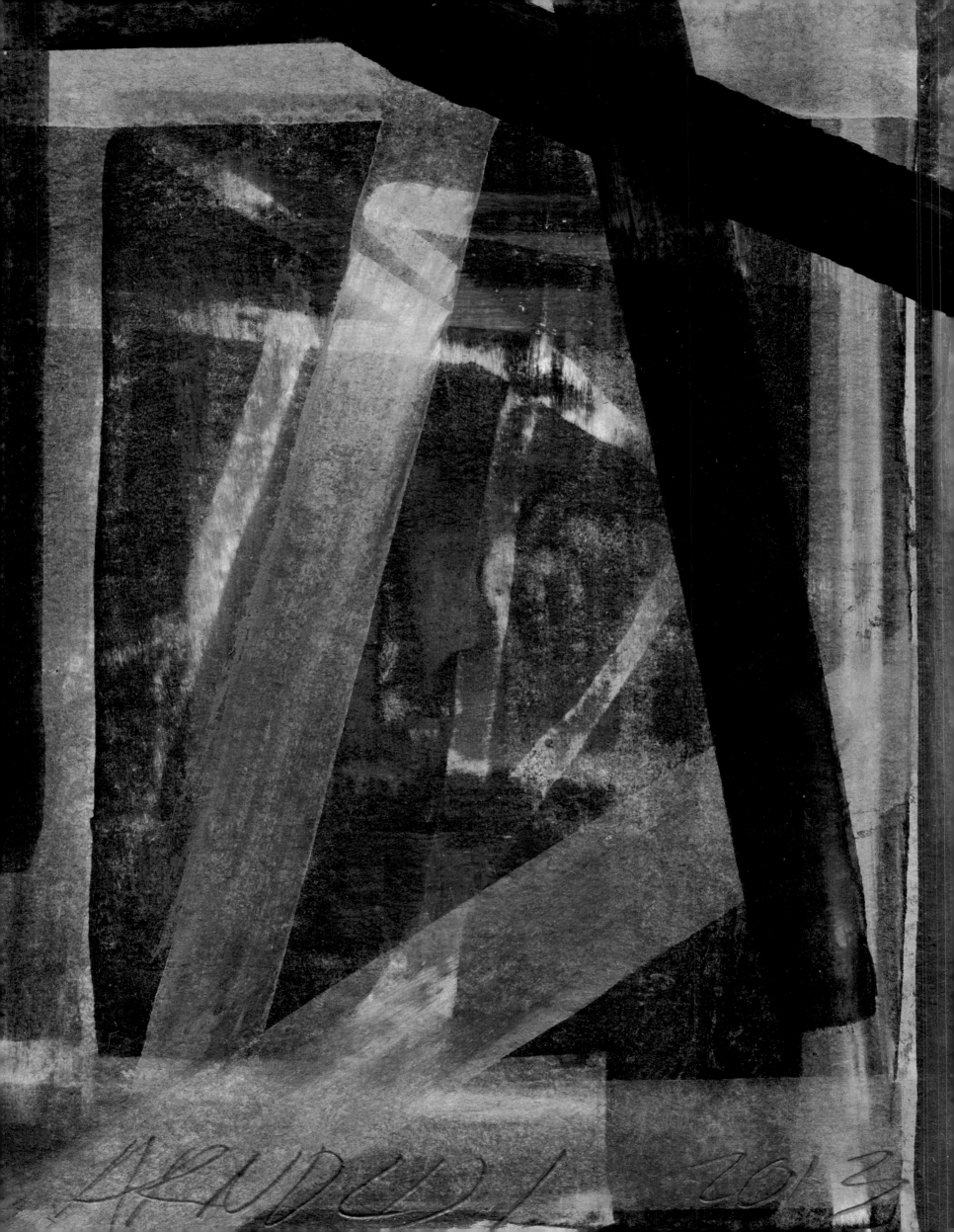

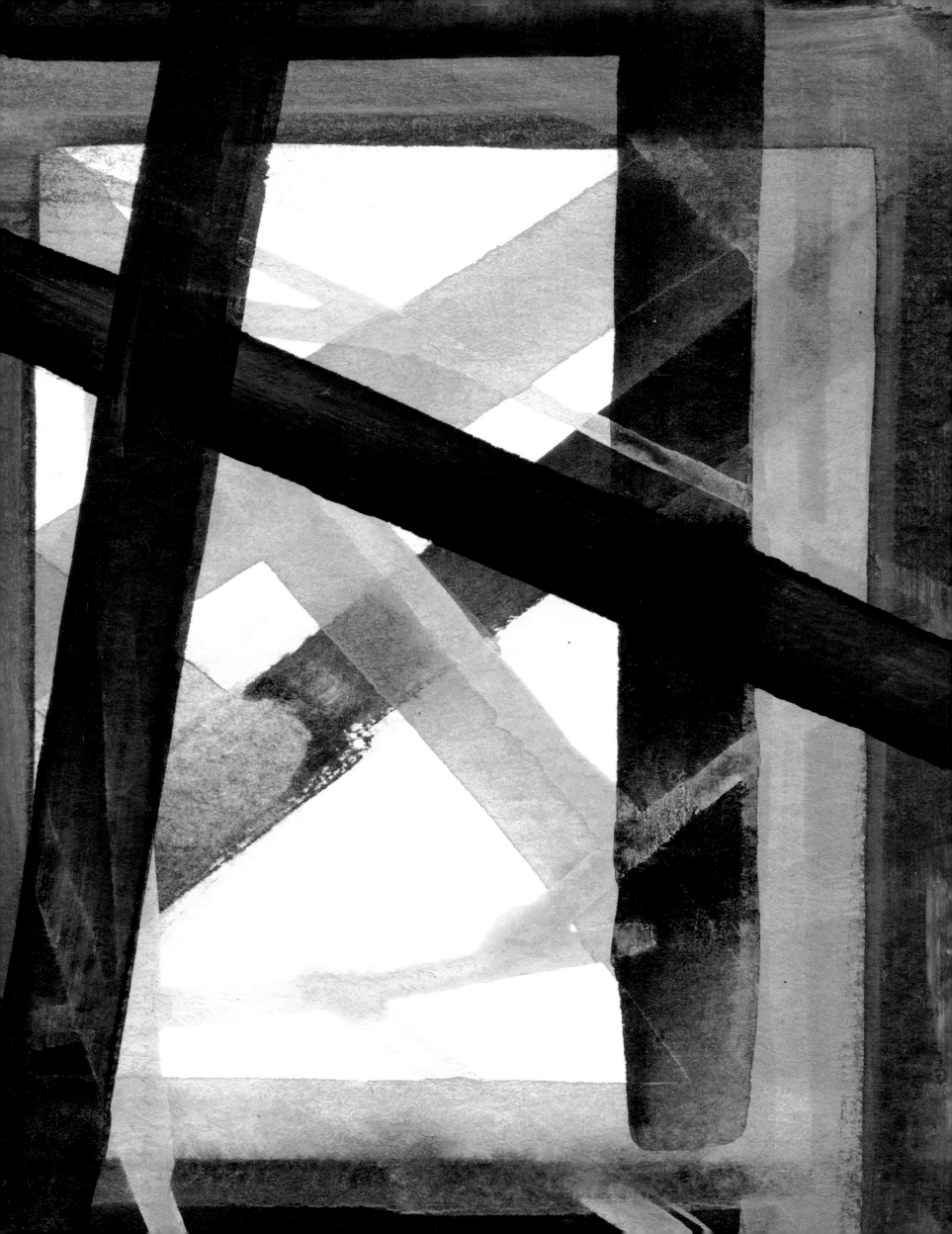

PLATE 92 | UNTITLED, 2013 GOUACHE ON PAPER, 6 x 4¼ INCHES

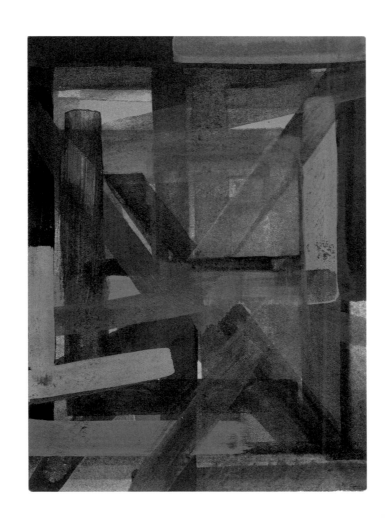

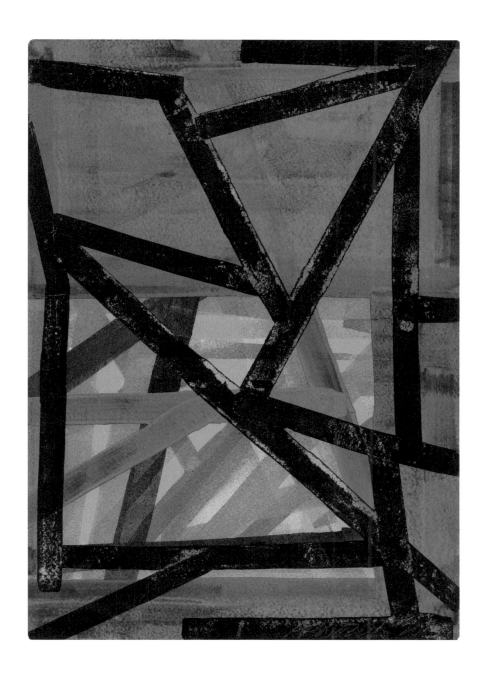

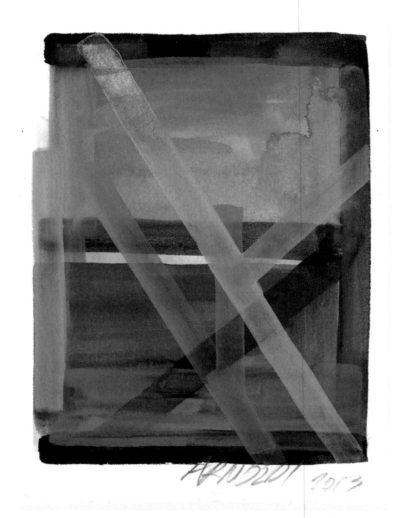

PLATE 94 | UNTITLED, 2013 GOUACHE ON PAPER, 5¾ x 4½ INCHES

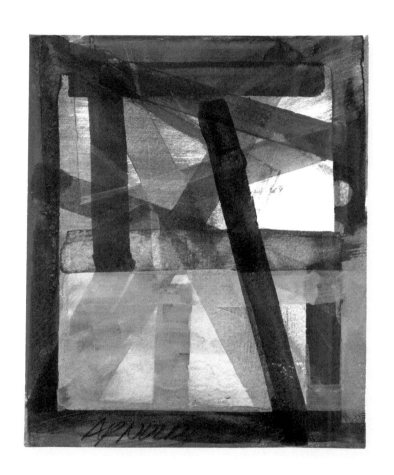

PLATE 95 | UNTITLED, 2013 GOUACHE ON PAPER, 5⅛ x 4 INCHES

PLATE 96 | UNTITLED, 2013 GOUACHE ON PAPER, 8 x 6 INCHES

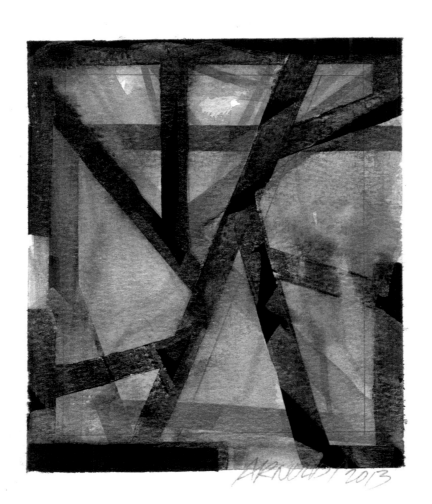

PLATE 97 | UNTITLED, 2015 GOUACHE ON PAPER, 12¾ x 11 INCHES

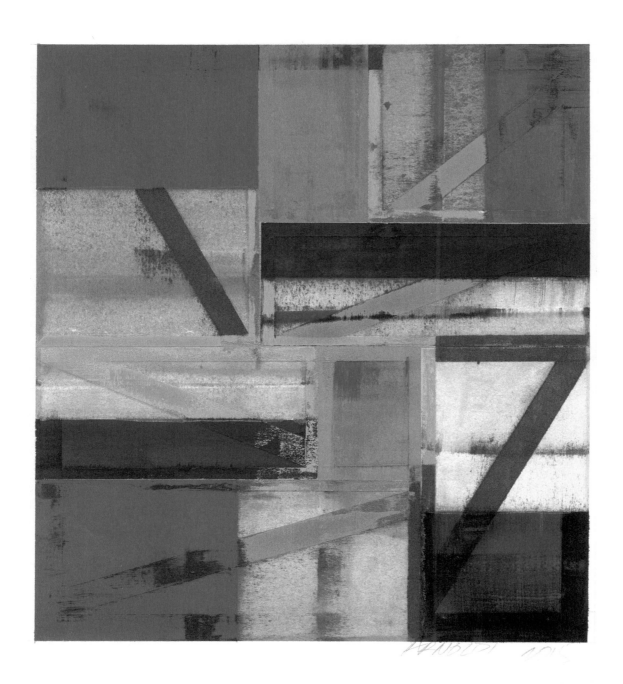

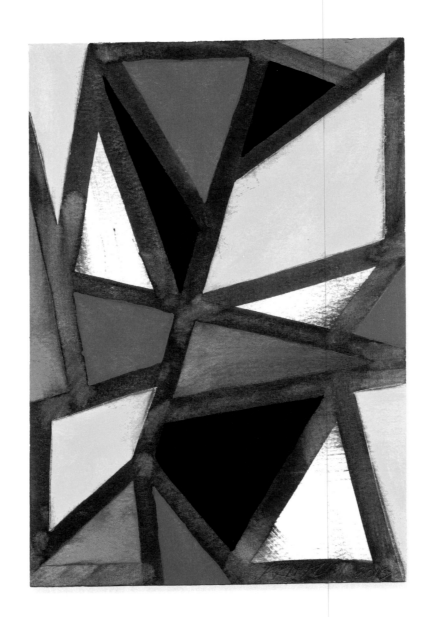

PLATE 98 | UNTITLED, 2013 GOUACHE ON PAPER, 9 x 6 INCHES

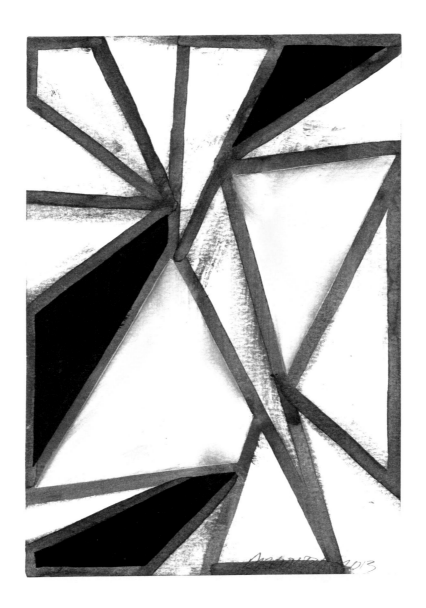

PLATE 99 | UNTITLED, 2013 GOUACHE ON PAPER, 9 x 6 INCHES

PLATE 100 | **UNTITLED, 2014** GOUACHE ON PAPER, 8 x 8 INCHES

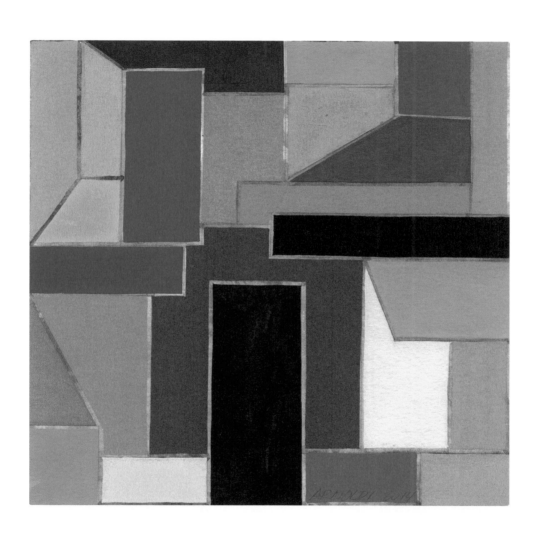

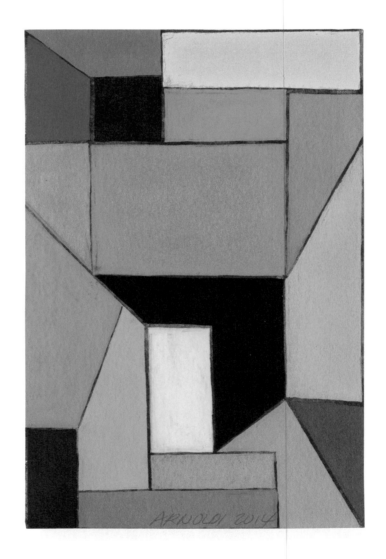

PLATE 101 | UNTITLED, 2014 GOUACHE ON PAPER, 6 x 4 INCHES

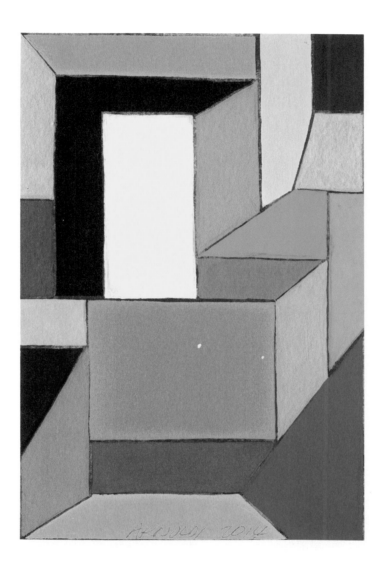

PLATE 102 | UNTITLED, 2014 GOUACHE ON PAPER, 6 x 4 INCHES

PLATE 103 | **UNTITLED, 2014** GOUACHE ON PAPER, 10 x 7 INCHES

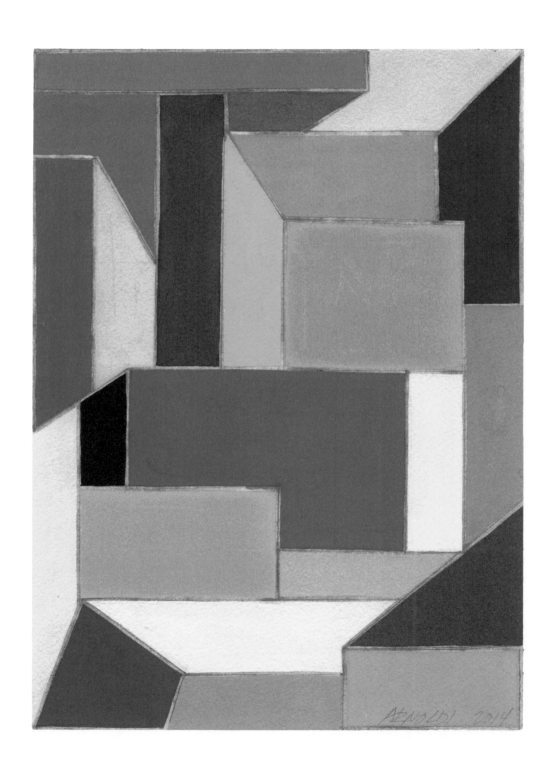

PLATE 104 | UNTITLED, 2014 GOUACHE ON PAPER, 6 x 4 INCHES

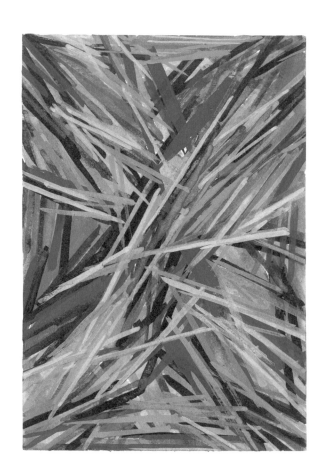

PLATE 105 | **UNTITLED, 2015** GOUACHE ON PAPER, 6 x 4 INCHES

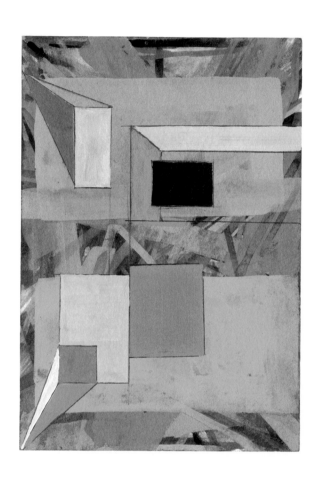

PLATE 106 | UNTITLED, 2015 GOUACHE ON PAPER, 4 x 8 INCHES

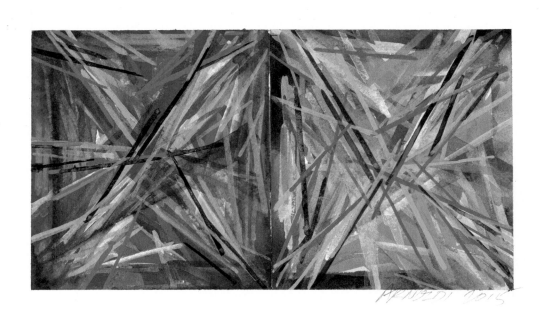

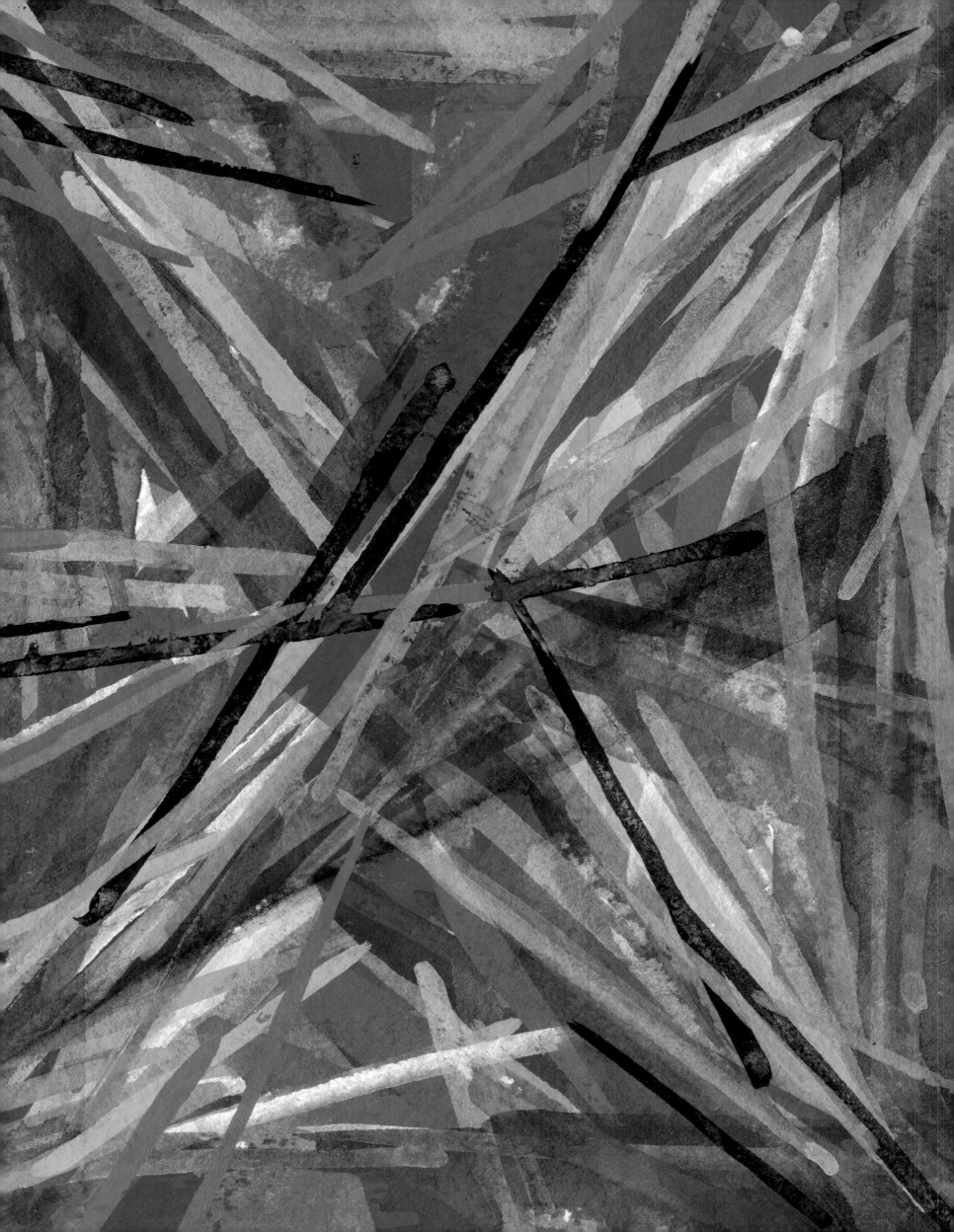

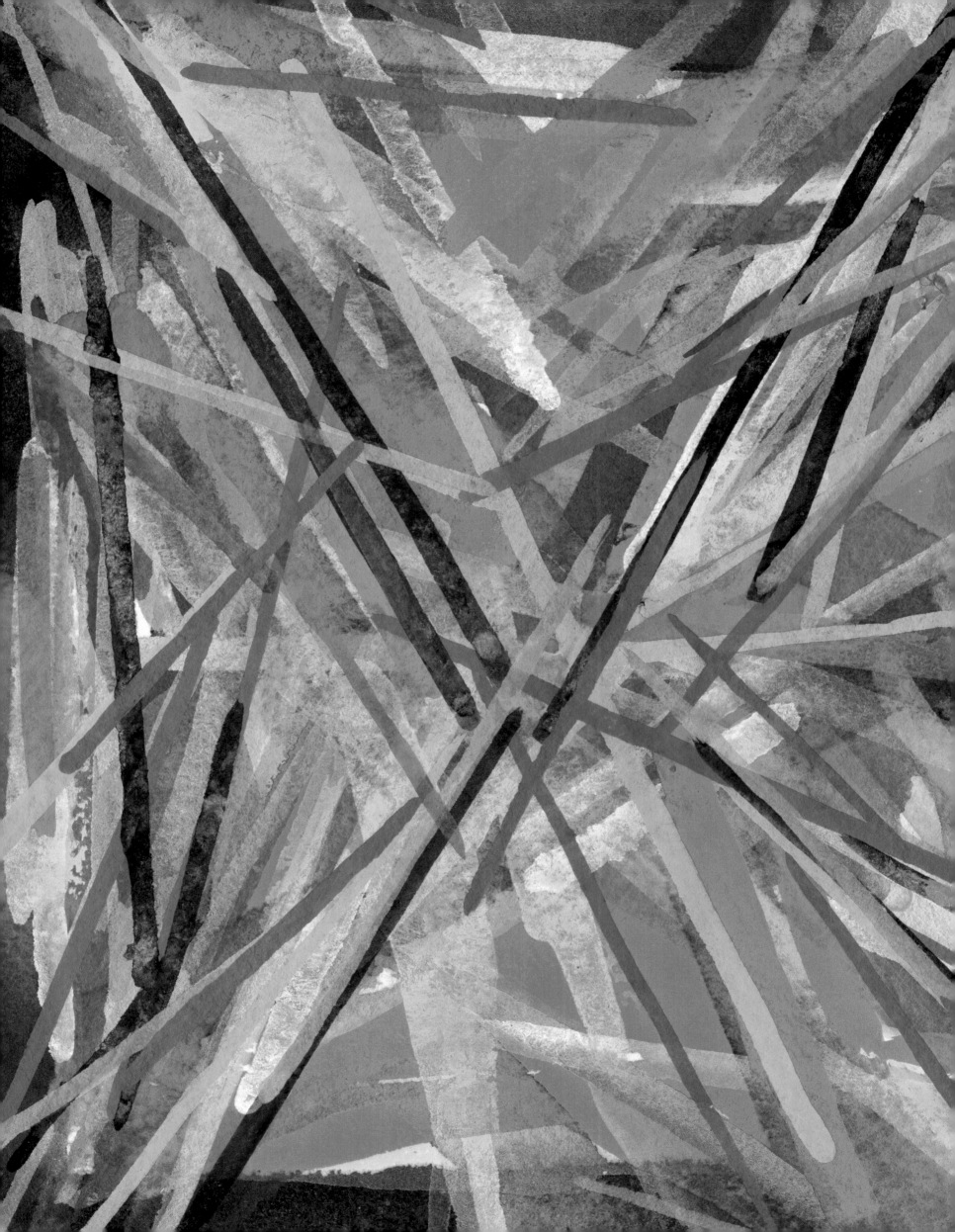

PLATE 107 | **UNTITLED, 2015** GOUACHE ON PAPER, 12 x 9 INCHES

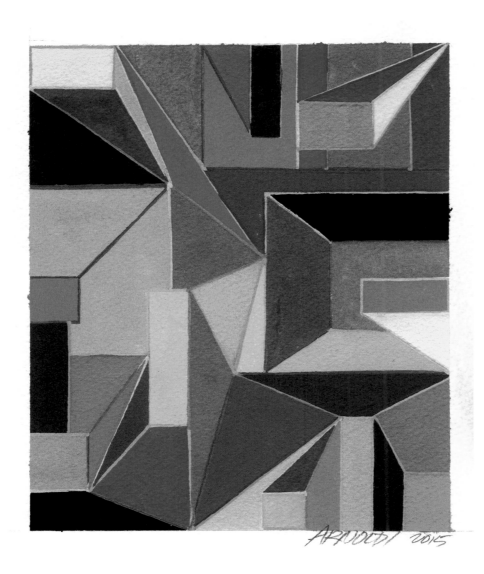

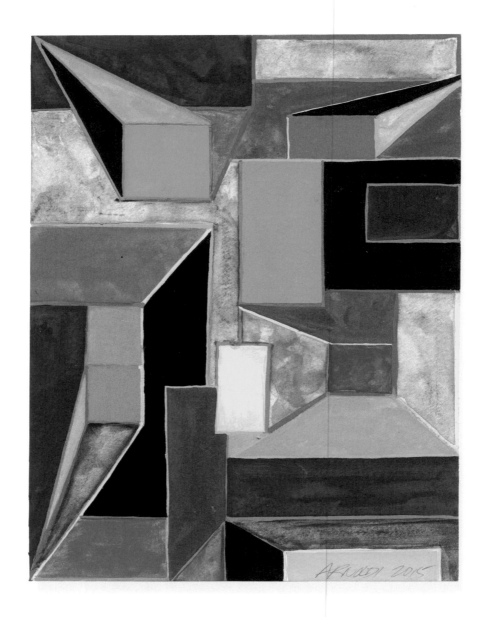

PLATE 108 | UNTITLED, 2015 GOUACHE ON PAPER, 8 × 6 INCHES

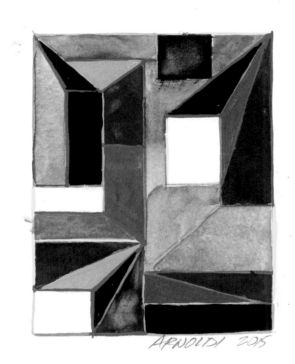

PLATE 109 | UNTITLED, 2015 GOUACHE ON PAPER, 6 x 4 INCHES

PLATE 110 | **UNTITLED, 2015** GOUACHE ON PAPER, 12 x 9 INCHES

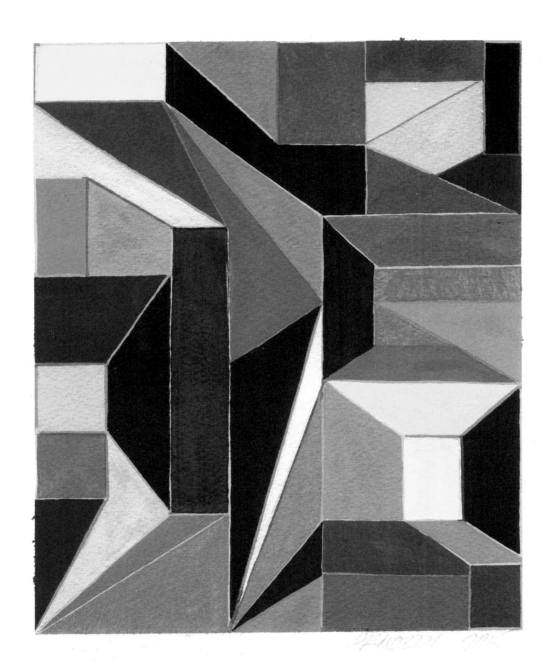

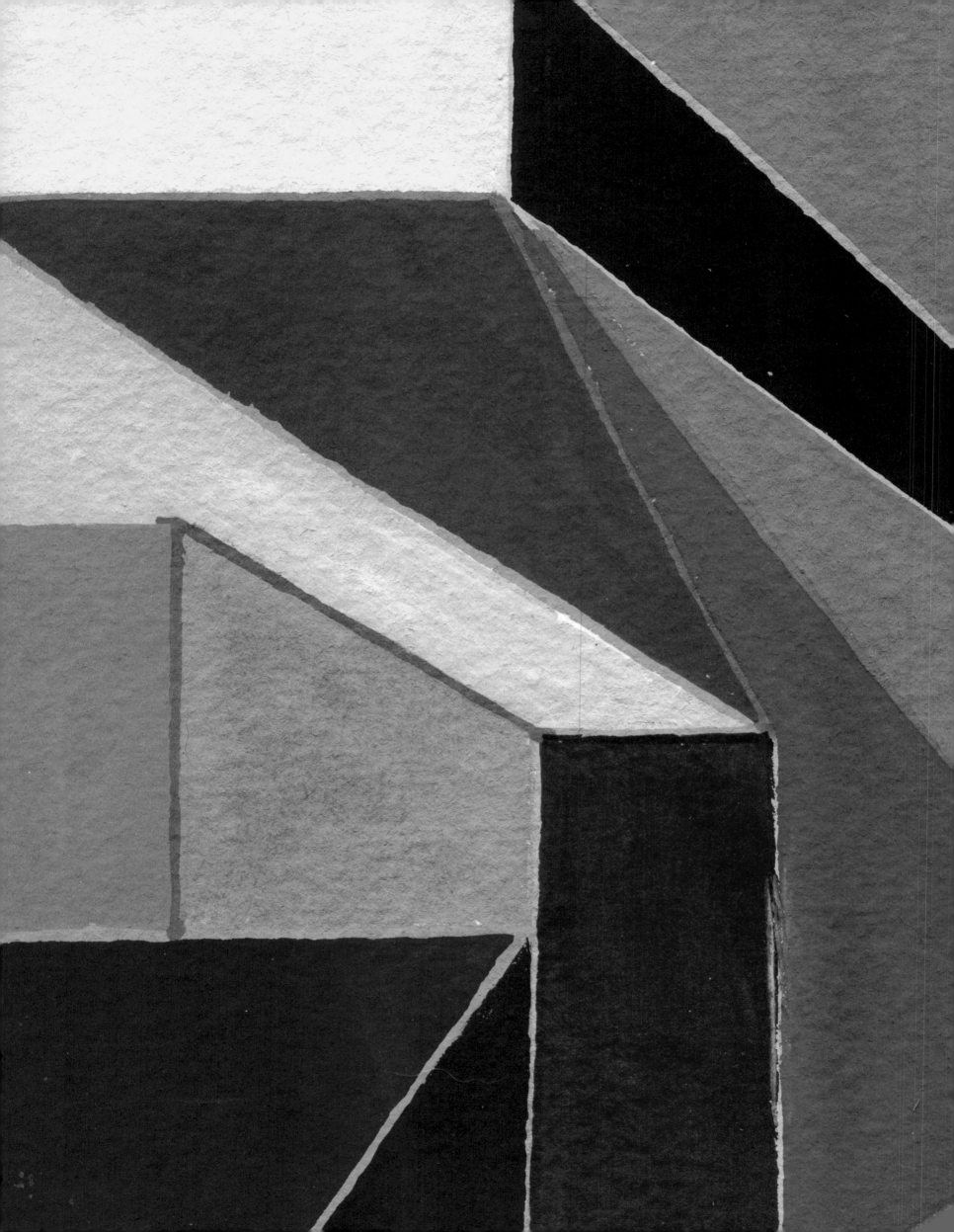

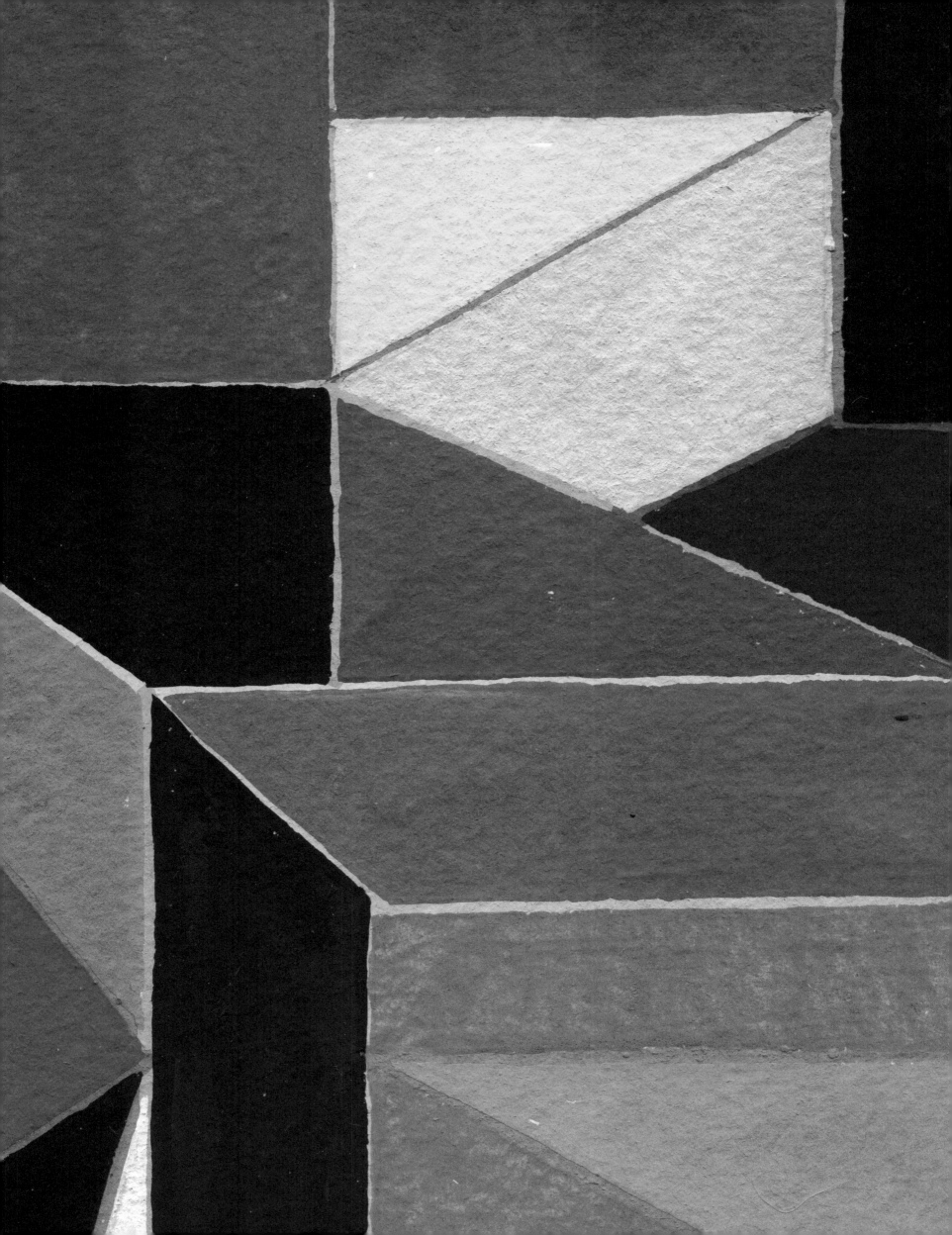

PLATE 111 | UNTITLED, 2015 GOUACHE ON PAPER, 10 x 10 INCHES

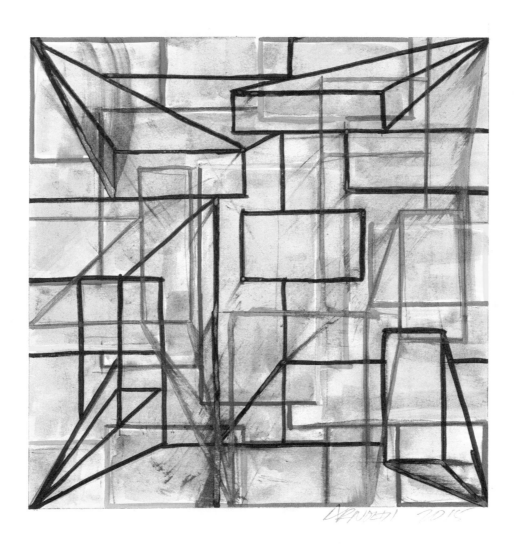

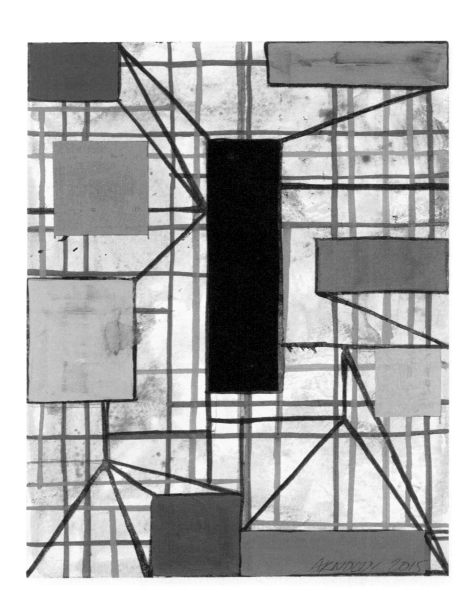

PLATE 113 | **UNTITLED, 2015** GOUACHE ON PAPER, 8 x 4 INCHES

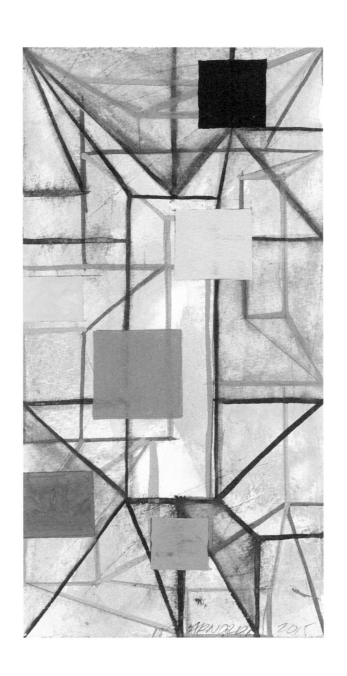

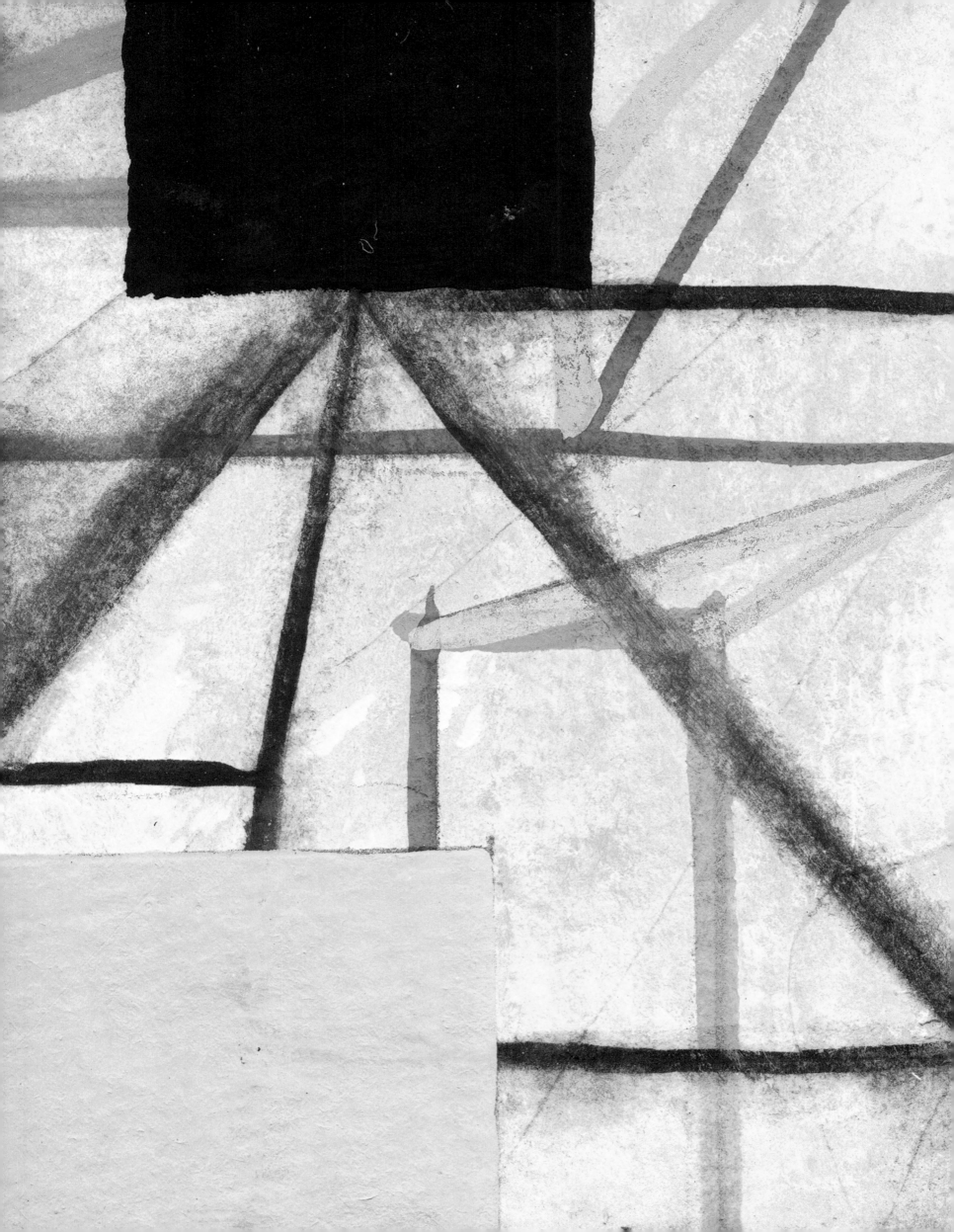

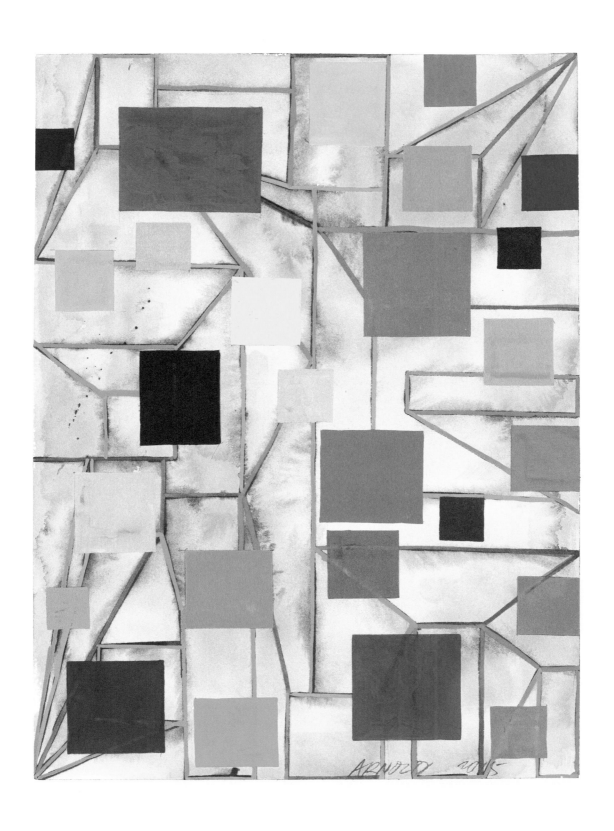

PLATE 115 | **UNTITLED, 2016** INK ON VELLUM, 17 x 14 INCHES

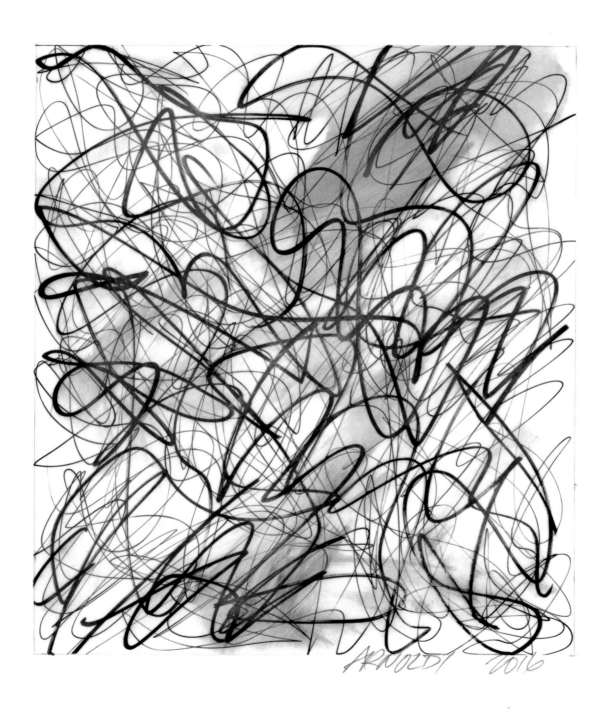

ARNOLDI 2016

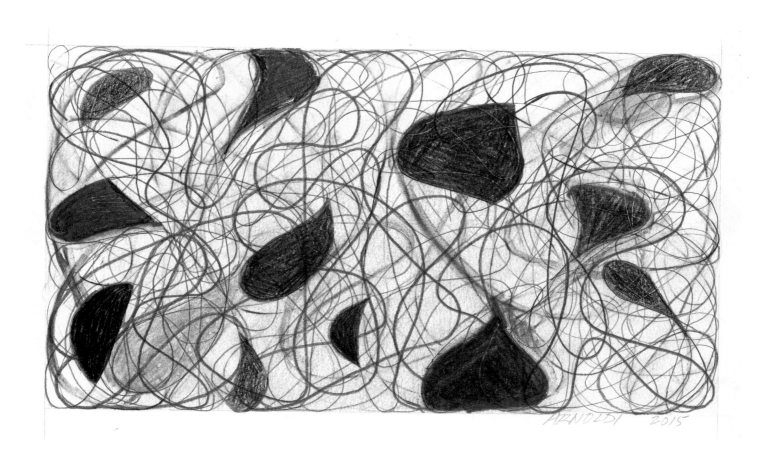

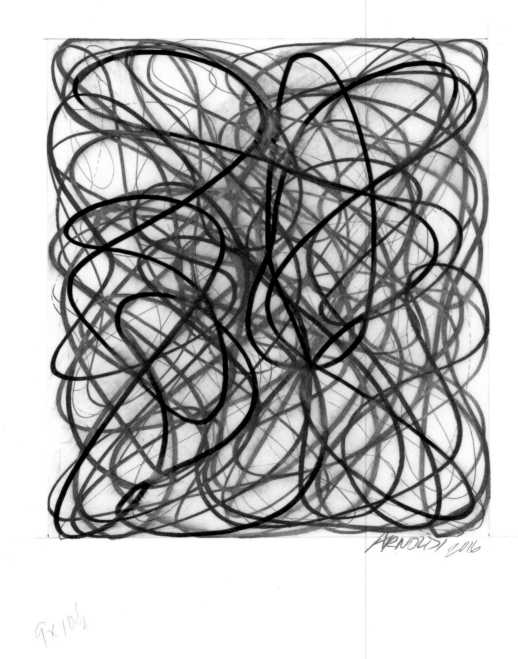

ARNOLDI 2016

9 x 10½

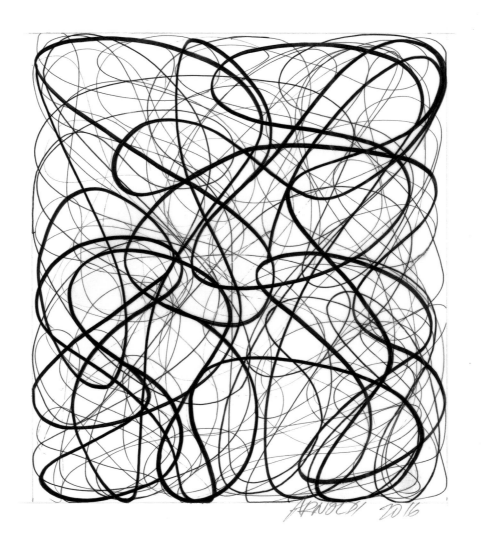

ARNOLDI 2016

PLATE 119 | **UNTITLED, 2016** PENCIL ON PAPER, 8 x 6 INCHES

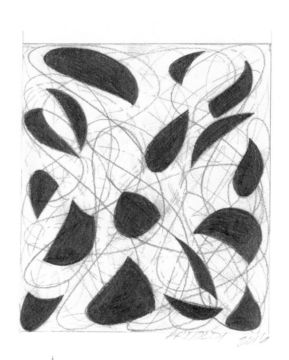

PLATE 120 | **UNTITLED, 2016** CHARCOAL ON PAPER, 43 x 38½ INCHES

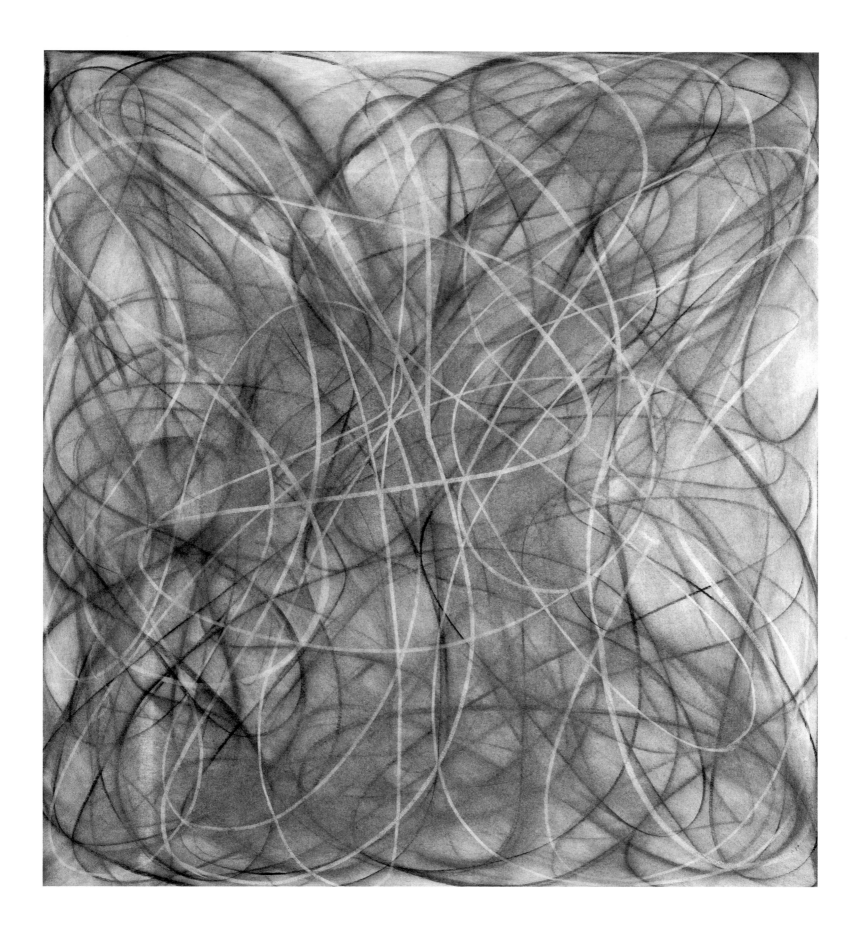

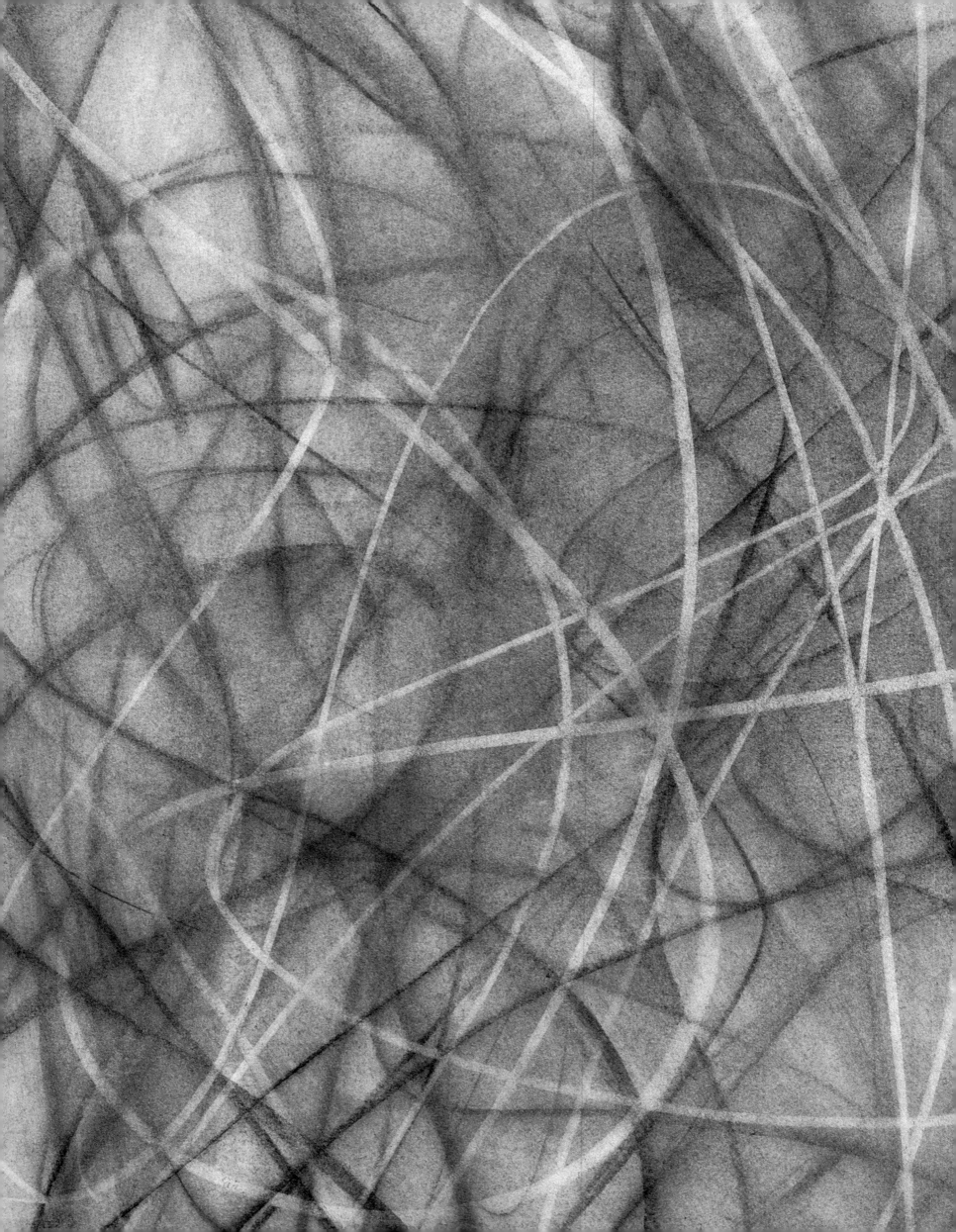

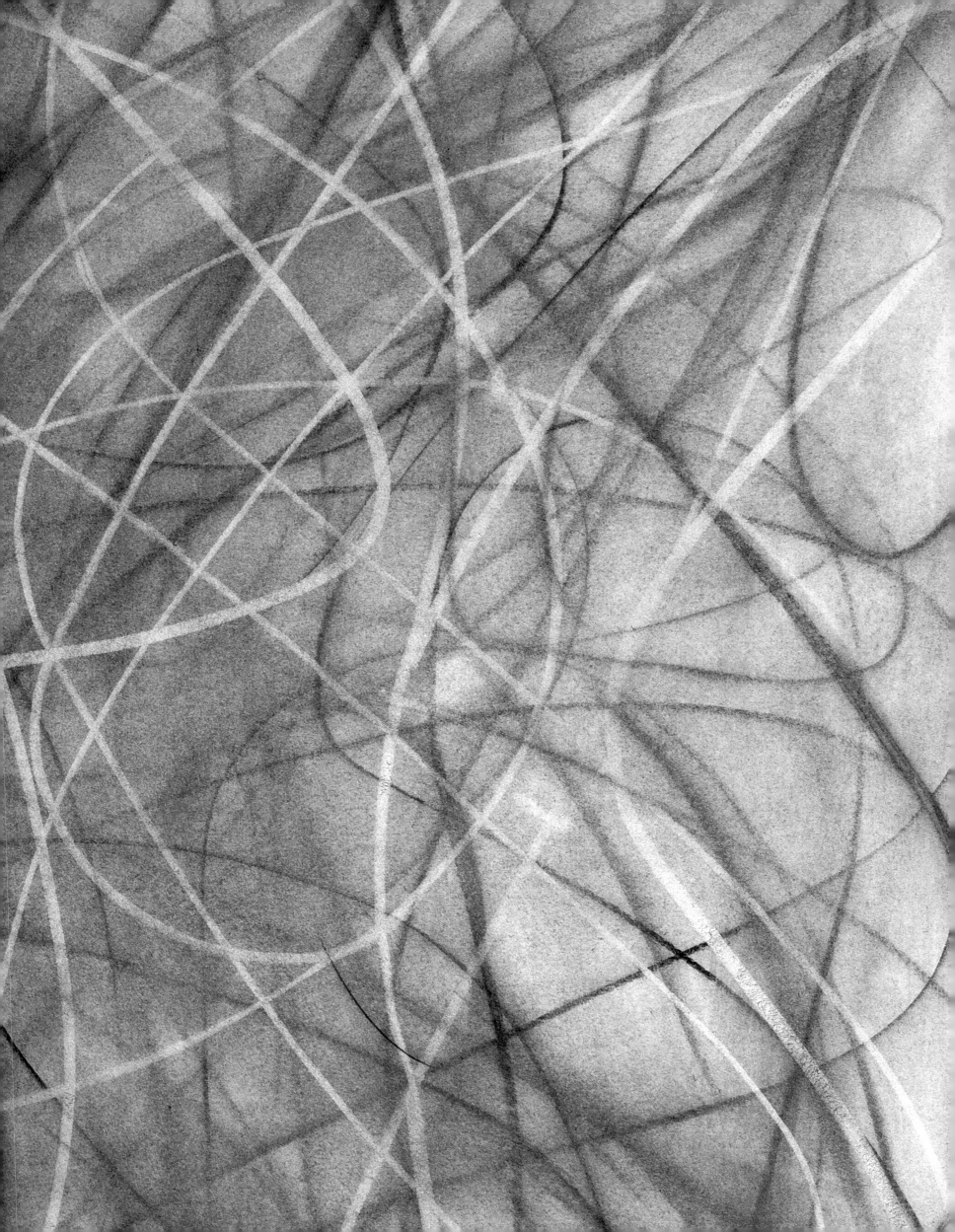

PLATE 121 | **UNTITLED, 2016** CHARCOAL ON PAPER, 43 x 36 INCHES

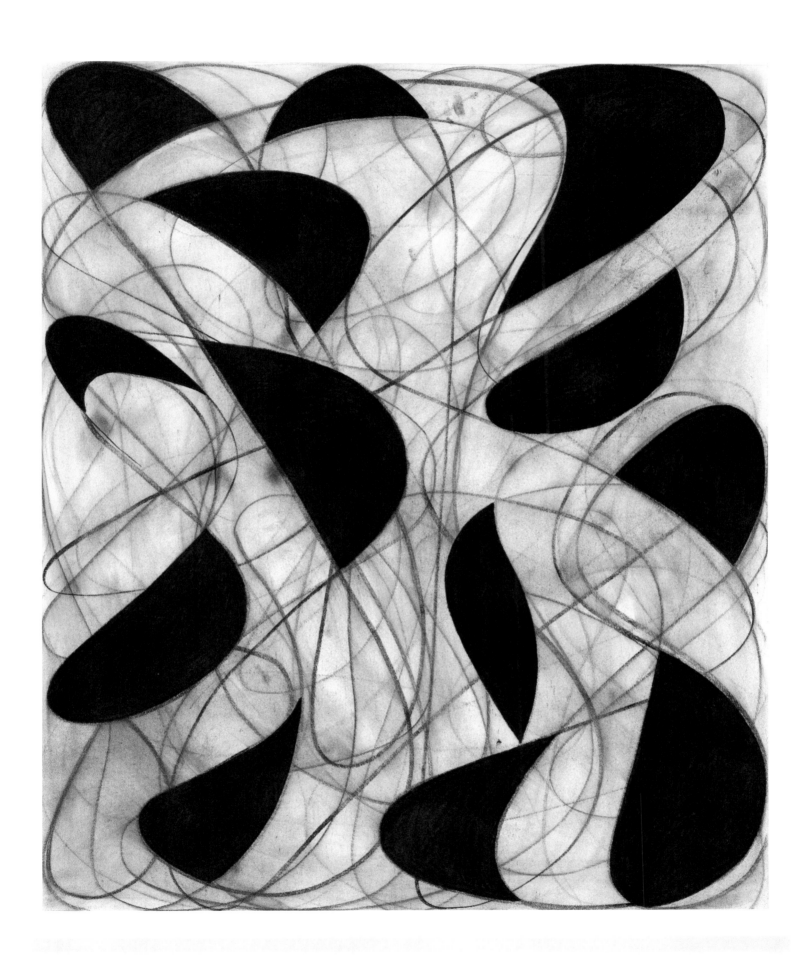

PLATE 122 | **UNTITLED, 2015** GOUACHE ON PAPER, 12 x 9 INCHES

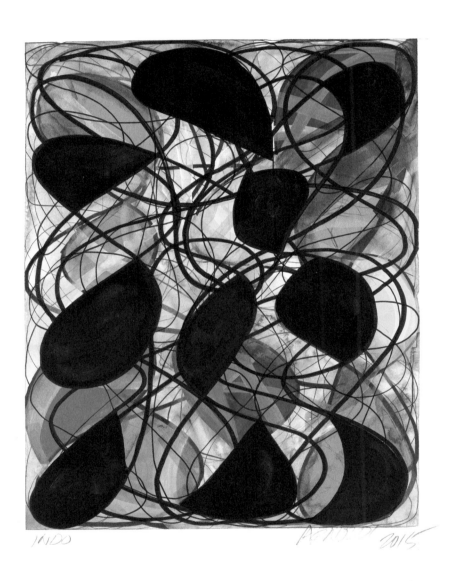

INDO 2015

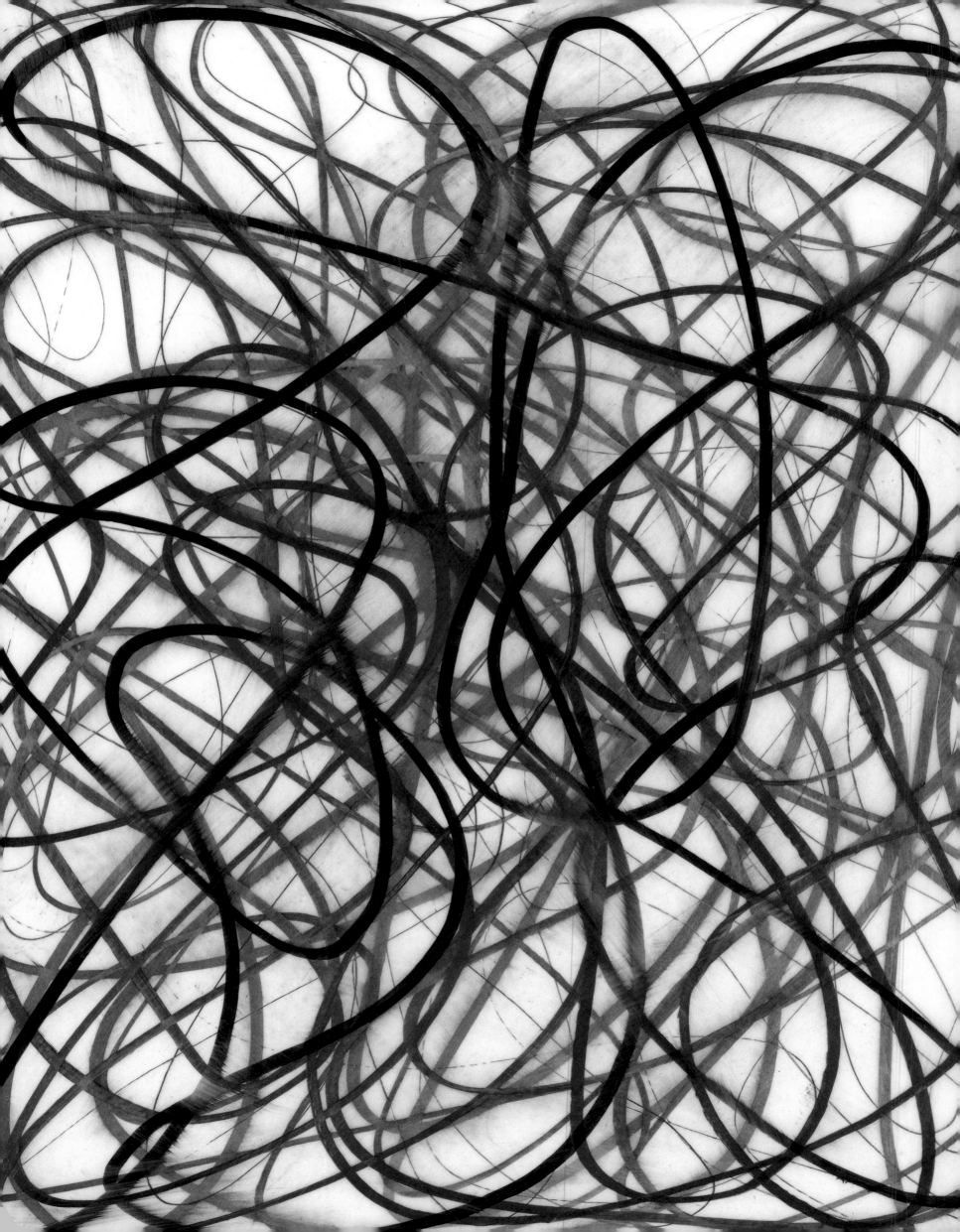

BIOGRAPHY

Born April 10, 1946, in Dayton, Ohio

Lives in Malibu, California; Works in Venice, California

Attended Chouinard Art Institute, Los Angeles, 1968

AWARDS

Young Talent Award
Los Angeles County Museum of Art
Contemporary Arts Council, 1969

Wittkowsky Award
Art Institute of Chicago, 1972

Artist Fellowship
National Endowment for the Arts, 1974

John Simon Guggenheim Fellowship, 1975

Maestro Fellowship
California Arts Council, 1982

Artist Fellowship
National Endowment for the Arts, 1982

SOLO MUSEUM EXHIBITIONS

Charles Arnoldi
Oceanside Museum of Art, Oceanside, California, 2013

Charles Arnoldi: Wood
Frederick R. Weisman Museum of Art, Pepperdine
University, Malibu, California (catalogue), 2008

Charles Arnoldi
Museum of Design Art and Architecture, Culver City,
California, 2006

Charles Arnoldi, *Harmony of Line and Color*
Busan Metropolitan Art Museum, Busan, Korea
(catalogue), 2002

Charles Arnoldi, A Mid-Career Survey: 1970 – 1996
Fred Hoffman Fine Art, Santa Monica, California
(catalogue), 1996

Arnoldi: Just Bronze
University Art Museum, California State University,
Long Beach, California (catalogue), 1987

Arnoldi: Recent Paintings
University of Missouri-Kansas City Gallery of Art,
Kansas City, Missouri (catalogue), 1986

Charles Arnoldi, A Survey: 1971-1986
Arts Club of Chicago, Chicago, Illinois (catalogue), 1986

Charles Arnoldi: Unique Prints
Los Angeles County Museum of Art, Los Angeles,
California (catalogue), 1984

SELECTED GROUP EXHIBITIONS

Another Look at the Permanent Collection, Anderson Collection, Stanford University Art Museum, 2015

Pacific Standard Time (organized by the Getty), Martin-Gropius-Bau, Berlin, Germany, 2012

California Abstract Painting 1952-2011, Curated by James Hayward, Woodbury University Art Gallery, 2011

Swell, Metro Pictures, Nyehaus, Friedrich Petzel Gallery, New York, NY, 2010

15 Minutes of Fame: Portraits from Ansel Adams to Andy Warhol, Orange County Museum of Art, 2010

Made in California, Frederick R. Weisman Museum of Art, Pepperdine University, Malibu, California, 2007

Driven to Abstraction: Southern California and the Non-Objective World, 1950-1980, Riverside Art Museum, Riverside, California, 2006

The First 80 Years, 1925-2005, Los Angeles Art Association/ Gallery 825, Los Angeles, California (catalogue), 2005

Paint on Metal, Tucson Museum of Art, Tucson, Arizona (catalogue), 2005

Lost But Found: Assemblage, Collage and Sculpture, 1920-2002, Norton Simon Museum, Pasadena, California (catalogue), 2004

Celebrating Modern Art: The Anderson Collection, San Francisco Museum of Modern Art, San Francisco, California (catalogue), 2000

Radical Past: Contemporary Art and Music in Pasadena, 1960-1974, Armory Center for the Arts, Pasadena, California (catalogue), 1999

70s in 80s: Printmaking Now, Museum of Fine Arts, Boston, Massachusetts (catalogue), 1986

The 38th Corcoran Biennial Exhibition of American Painting: Second Western States Exhibition, Corcoran Gallery of Art, Washington, D.C. (catalogue), 1983

1981 Biennial Exhibition, Whitney Museum of Art, New York, New York (catalogue), 1981

Los Angeles Prints, 1883-1980, Los Angeles County Museum of Art, Los Angeles, California (catalogue), 1981

Painting and Sculpture Today, Indianapolis Museum of Art, Indianapolis, Indiana (catalogue), 1976 and 1978

Painting and Sculpture in California: The Modern Era, San Francisco Museum of Modern Art, San Francisco, California (catalogue); also shown at the National Collection of Fine Arts, Smithsonian Institute, Washington, D.C. 1976

Fifteen Los Angeles Artists, Pasadena Art Museum, Pasadena, California (catalogue), 1972

PUBLIC COLLECTIONS

Ackland Art Museum, University of North Carolina, Chapel Hill, North Carolina

Albright-Knox Art Gallery, Buffalo, New York

Art Institute of Chicago, Chicago, Illinois

Berkeley Art Museum and Pacific Film Archive, University of California, Berkeley, California

Boise Art Museum, Boise, Idaho

The Contemporary Museum, Honolulu, Hawaii

Denver Art Museum, Denver, Colorado

Guggenheim Bilbao, Bilbao, Spain

Hammer Museum, Los Angeles, CA

Samuel P. Harn Museum of Art, University of Florida, Gainesville, Florida

Kemper Museum of Contemporary Art, Kansas City, Missouri

Laumeier Sculpture Park, St. Louis, Missouri

Long Beach Musuem of Art, Long Beach, CA

Los Angeles County Museum of Art, Los Angeles, California

Memphis Brooks Museum, Memphis, Tennessee

The Menil Collection, Houston, Texas

Metropolitan Museum of Art, New York, New York

Pérez Art Museum Miami, Miami, Florida

Milwaukee Art Museum, Milwaukee, Wisconsin

Museum of Contemporary Art, Chicago, Illinois

Museum of Fine Arts, Houston, Texas

Museum of Modern Art, New York, New York

National Gallery of Art, Sydney, Australia

Nelson-Atkins Museum of Art, Kansas City, Missouri

Nevada Museum of Art, Reno, Nevada

Newark Museum, Newark, New Jersey

Norton Simon Museum, Pasadena, California

Orange County Museum of Art, Newport Beach, California

Palm Springs Art Museum, Palm Springs, California

Perez Art Museum Miami, Miami, FL

Portland Art Museum, Portland, Oregon

San Diego Museum of Art, San Diego, California

San Francisco Museum of Modern Art, San Francisco, California

San Jose Museum of Art, San Jose, California

Santa Barbara Museum of Art, Santa Barbara, California

Jordan D. Schnitzer Family Foundation, Portland, OR

Scottsdale Museum of Contemporary Art, Scottsdale, Arizona

Seattle Art Museum, Seattle, Washington

Smithsonian American Art Museum, Washington, D.C.

University Art Museum, California State University, Long Beach, California

Frederick R. Weisman Art Foundation, Los Angeles, California

Jane Voorhees Zimmerli Art Museum, Rutgers University, New Brunswick, New Jersey

Whitney Museum of American Art, New York, New York

ACKNOWLEDGMENTS

I want to acknowledge and thank Charlotte Jackson and David Chickey and his team at Radius Books for working on this book, which represents my passion for drawing and offers an intimate look at my process.

Thanks to Bruce Guenther for his insightful text and deep understanding of my work.

Special thanks to Dave Hickey for sitting in conversation with me during the early stages of the book.

Thanks to Jacob Melchi, my studio manager , for his patience and hard work. He participated on every level in the preparation of this book, including the photography, color proofing, and organization of the drawings.

Finally, and most importantly, my deepest gratitude to my wife Katie, and my children Ryland and Natalie.

This publication would not have happened without the generous support of the following, who were all committed to seeing this book come to fruition:

Beth Rudin DeWoody

Art Ellsworth & Marvin J. Wilkinson

Joan & Mitchell Markow

Martin Muller

Jordan D. Schnitzer

Peter & Turkey Stremmel

Private Donors

RADIUS BOOKS is a tax-exempt 501(c)(3) nonprofit organization whose mission is to encourage, promote, and publish books of artistic and cultural value.

This book was produced in collaboration with Art Santa Fe Presents, Inc., a tax exempt 501(c) 3 non-profit organization whose mission is to further the understanding of contemporary art through a variety of public programs including art criticism and the publication of artists books.

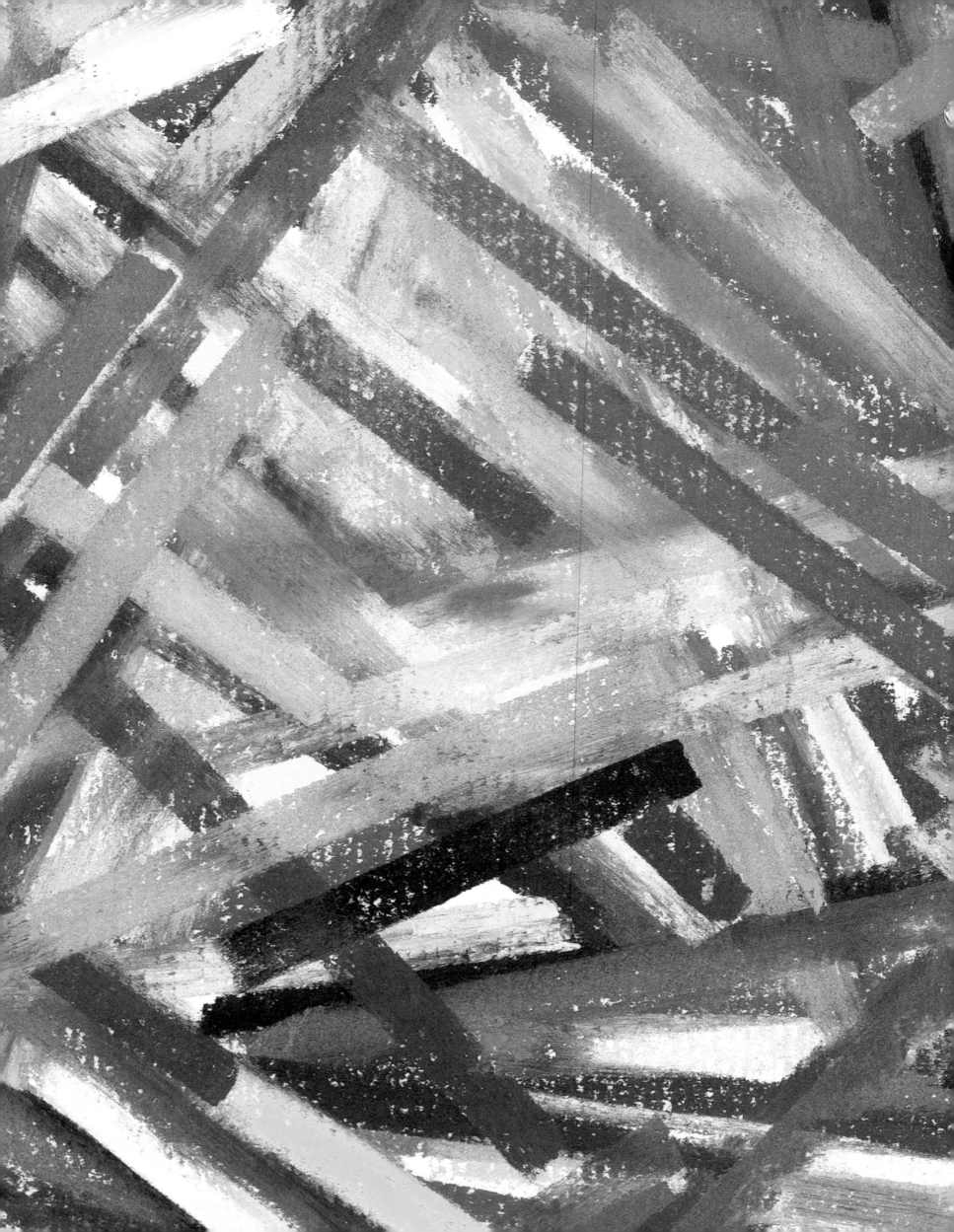